BETWEEN BRUSHSTROKES

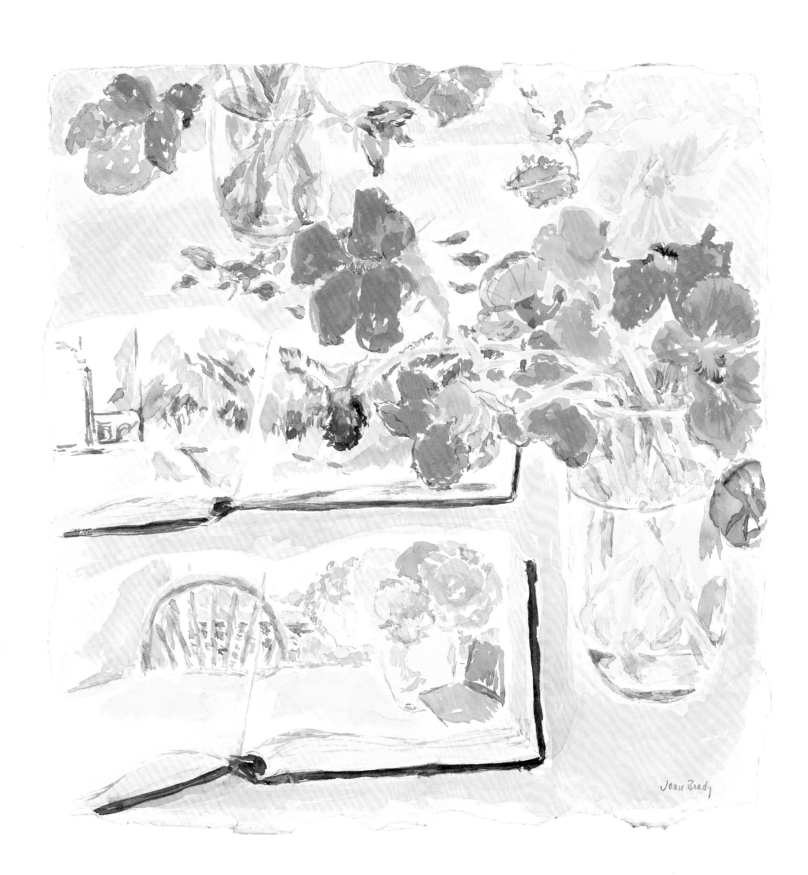

BETWEEN BRUSHSTROKES

Paintings, Poetry, & Prose by

JOAN BRADY

FOREWORD BY SUE SCOTT

HUDSON HILLS PRESS · NEW YORK AND MANCHESTER

FIRST EDITION

Copyright © 2008 Joan Brady
Foreword © 2008 by Sue Scott

Published in the United States by Hudson Hills Press LLC,
3556 Main Street, Manchester, Vermont 05254.

Distributed in the United States, its territories and possessions, and Canada by National Book Network, Inc. Distributed outside of North America by Antique Collectors' Club, Ltd.

PRODUCTION CREDITS

Executive Director: Leslie Pell van Breen
Editor: Renate Stendhal, Point Reyes, California
Proofreader: Jan Ronish, Lancaster, New Hampshire
Designer: Christopher Kuntze, Whitefield, New Hampshire
Photographs of paintings by Michael Newman, Laumont Editions,
 Caspari, Chod Lang, Allan Carlisle
Color separations by Digital Arts Imaging, Flemington, New Jersey
Printed by Capital Offset Company, Concord, New Hampshire
Bound by Acme Bookbinding, Charlestown, Massachusetts
Founding Publisher: Paul Anbinder

FRONT COVER: *Lotus in Red* (detail), 2004; Watercolor on paper; 10½ × 9 inches; Collection of the artist

BACK COVER: *Pink Pitcherful* (detail), 2004; Watercolor on paper; 23 × 17½ inches; Collection of Mr. and Mrs. Richard F. Brueckner

FRONTISPIECE: *Nasturtiums and Sketchbooks,* 2005; Watercolor on paper; 15 × 15 inches; Collection of the artist

LIBRARY OF CONGRESS CATALOGING-IN-PUBLICATION DATA

Brady, Joan B.
 Between brushstrokes : paintings, poetry, & prose / by Joan Brady ; foreword by Sue Scott. — 1st ed.
 p. cm.
 ISBN 978-1-55595-301-0
 1. Brady, Joan B.—Themes, motives. I. Title.
 ND1839.B693A4 2008
 759.13—dc22 2008030457

Dedicated to
the Divine Feminine
in all beings

Contents

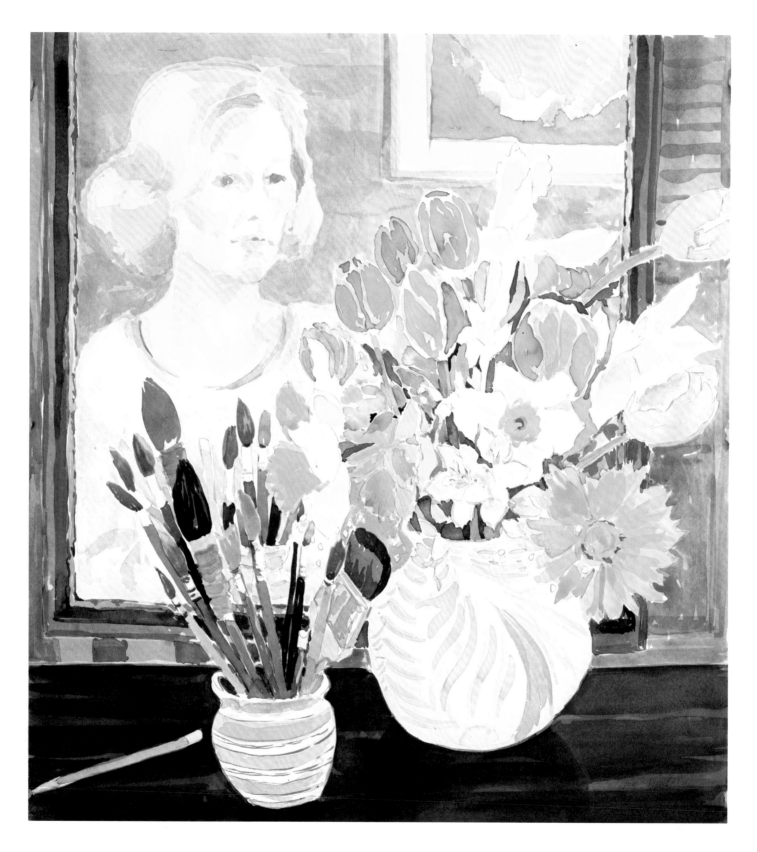

Self-Portrait in Studio, 1983; Watercolor on paper; 22 × 22 inches; Collection of Mr. and Mrs. Wilson Nolen

And Now What?

A look in the rearview mirror …
How far back my story, my passions began!
Weaving together loose and broken threads,
pulling together the quilt of my life.

A life of listening to the voice. Sometimes
where others didn't want me to go.
Learning lessons, making beauty,
making messy, making love.

A life that could be dismissed as a piece of cake,
a silver spoon, noblesse oblige.
Underneath the privileged expression,
a fierce and unrelenting calling.

I have too much to say
and too much not to say.
Also, nothing left to say.
But now, I must begin.

Foreword | SUE SCOTT

Robert Rauschenberg once said, now famously, "Painting relates to both art and life. Neither can be made. (I try to act in that gap between the two.)" For Joan Brady, the inextricable link between art and life is equally pronounced. If Rauschenberg saw art in objects scavenged from daily life—an old quilt, a used tire or stuffed goat that he transformed into combines or photographs and old newspapers he made into collages—Joan Brady finds the objects of her inspiration in scenes from her daily life: her home and family; her studio; the beautiful gardens that surround her home in New Jersey; and the varied experiences of travel that have come from "voyaging out," both physically and spiritually.

There is something both magical and comforting in revisiting subject matter. "Every object that appears . . . and reappears . . . in my paintings has a story, a memory, a meaning," Brady says, "Cranberry glass, pieces of china, the blue and white tiled kitchen table, wall papers, material which haven't changed in thirty years or more. And, of course, the garden. . . . From the end of April through June, whether painting, cultivating, arranging, enjoying, I'm immersed in the garden."[1]

Claude Monet painted countless versions of his gardens at Giverny, creating scenes that are iconic in the development of 20th-century art. Lucien Freud, who painted and repainted favorite models, also recognized the powerful aspects of revisiting subject matter: "The painter's obsession with his subject is all that he needs to drive him to work. People are driven towards making works of art, not by familiarity with the process by which this is done, but by a necessity to communicate their feelings about the object of their choice with such intensity that these feelings become infectious."[2] Freud uses the thick build-up of oil paint to explore fully the physicality and fleshiness of his sitters in much the way Brady uses the delicacy of watercolor—and the whiteness between the brushstrokes—to portray the beauty and the light of her surroundings. For both artists, the medium is inextricably tied to the message.

Brady does not view watercolor as the difficult, unforgiving medium it is considered by many. Indeed, it was through watercolor, particularly the possibility for spontaneity, accident and chance—that Brady found her "handwriting" and developed her own language. The elusiveness and delicacy of watercolor appeals to her. As she notes, "Imagine holding a bird in your hand—you don't want to crush it, but you don't want to let it get away."

Brady knew from an early age that she wanted to be an artist. After majoring in art at college, she studied in the mid- to late fifties with the likes of Robert Brackman and George Gross at the Art Students League in New York, mostly doing figurative work. As the recent work, *Girl on Wolf, Remembering*, 2006, intimates, Brady's artistic desires—and understanding of the challenges—go back even further, to her childhood.

This painting is a departure from much of Brady's earlier work in that it is loaded with symbolism and rich with memory. A young girl straddles a wolf, brandishing a paintbrush in her left hand. (Brady is right-handed, but the left hand is connected to the intuitive side. Most self-portraits are actually reverse images because the artist is looking at him/herself in a mirror.) Subtle outlines of tan and gentle washes of lilac coupled with the child's pale blonde hair give the little girl an ethereal quality. The image of the head was taken from a watercolor by the well-known portrait artist Elizabeth Schoumatoff, done when Brady was four years old. In this setting, the young girl exudes a determination, looking directly at the viewer as if to say, "See, this is who I am."

Red rippling water, reflecting the rising sun and perhaps symbolizing the subconscious, stretches out behind her to purple mountains of China and an orange sky. Flowers flow over a waterfall; I see them as lotus flowers, a Buddhist symbol of spirituality and transformation. Brady mused that this imagery might be a metaphor for her desire to extend her work beyond painting flowers. The wolf is steady and calm beneath the child, untamed nature becalmed. Though the wolf is often considered an aggressor in our culture, the Native Americans see the wolf as a teacher and pathfinder, showing people how to trust their insights. Here, the wolf stands as both protector and guide. An owl flies over the scene directly towards the viewer, all seeing and wise. As with much of Brady's work, the white spaces are as poignant and punctuated as the line and color.

Another exceptional painting from this same period, *Lotus in Red*, 2003 (cover), features a single white lotus against a red background where the watercolor pools and flows in many gradations of this vibrant color.

Brady trained in the traditional media of oil, pastel and charcoal and it was not until the early sixties that she "accidentally discovered" watercolor, the medium that has come to define her as an artist. It is in one of her first watercolor paintings, *Jim and Nonie*, 1962, that we sense the beginning of Brady's mature style—combining line, negative space and abstract saturation of color to create a composition.

It is telling to read an *Artforum* review of Brady's 1990 solo exhibition at the New York gallery Tatistcheff & Company, Inc., written almost thirty years after she executed this early watercolor: "For more than two decades, she [Brady] has been known as an extremely talented watercolorist, working in a relaxed realist vein that admits detail without becoming tight or overly meticulous. Brady has developed a distinctive watercolor style that brings out essential shapes and masses through a tonal application of color."[3]

Another early watercolor *Antigua*, 1969 (p. 121) reveals her innate feel for the medium. Painted *en plein air*, a lone fisherman sits astride his boat in the water, his lobster cage at the fore. The waves crash behind him, but he floats in calm water rendered in washes of Windsor green, aqua, grey, and steely blue. One thinks of the Caribbean watercolors of Winslow Homer, an artist whom, along with other well-known American watercolorists such as Maurice Prendergast, Charles Demuth, and Nell Blaine, Brady admires. Again, what is striking about this work is the connection between medium and imagery. The allusion to water is made with water. "Watercolor has the property of water," Brady told me, "it goes where it wants to go. You can't dam it."

Brady clearly acknowledges the influence of the Impressionists and Post-Impressionists—particularly Henri Matisse but also Pierre Bonnard and Edouard Vuillard. For instance, she offers homage to Matisse in *Open Matisse*, 1987 (p. 75), in which an open book with two images of Matisse paintings in the foreground give way to flowers in vases in the middle ground which then gives way to a window, opening up to the gardens beyond. Brady uses the off-center composition, patterning, fresh color, and free brushwork that came to define the paintings of the Post-Impressionists. Certain paintings like *Blueberries in Studio*, 1984 (p. 66) and *May Garden from Living Room*, 1990 (p. 22) have the effect of shimmering, weightless screens created by floating color and pattern. Brady's use of white in *July Bouquet, Green Sofa*, 1983 (p. 17) explodes out into the deep green of the couch, like fireworks in a night sky.

There is something very American about Brady's work, not only a lightness and joy springing from an intimate connection to her subject matter but the formal qualities resulting from juxtaposing the whiteness of the paper with color that is at times diaphanous and other times densely saturated. In 1979, Brady saw an exhibition of Jane Freilicher's work at the Fischbach Gallery on 57th Street, New York. She was struck not only by Freilicher's stunning renditions of light and color, but by the unabashed

celebration of the same subjects Brady loved and painted. Brady was inspired by the fact that an artist who painted domestic scenes and landscapes was acknowledged by the greater art world. It is true Frielicher is known as an artist who works outside the mainstream but is nevertheless part of its flow; she once noted, "To strain after innovation, to worry about being 'on the cutting edge'—a phrase I hate—reflects concern for a place in history or for one's career rather than for the authenticity of one's own painting."[4]

Though abstraction has overwhelmed realism for most of the 20th century, it remains an important vein of American art. As the critic and abstract painter Stephen Westfall noted, "The past 50 years or so have been enriched by the advent and evolution of several art movements that opened up whole areas of practice by means of new materials and ways of seeing. It is thus understandable that during the same time hardly anyone has noticed that we have, in American art at least, been living through a golden age of painterly realism, especially landscape painting, one not likely to be repeated any time soon."[5] Westfall's described "golden age of realism" parallels Brady's own explorations and her search for a place in a world dominated by abstract and conceptual art.

This book brings together one hundred images representing forty-six years of Joan Brady's art and fifty-two pieces of her writing, partly culled from journals written over the past thirty years. Both expressions are intensely personal, realistic and yet punctuated with that which is unsaid. By leaving space for the viewer to fill in, Brady has found her voice with the pen as well as with the brush.

NOTES

1. All quotes from Joan Brady are from conversations and emails between the artist and author that took place May through July 2008.

2. "Lucien Freud, Some Thoughts on Painting," in Kristine Stiles and Peter Selz, *Theories and Documents of Contemporary Art, A Sourcebook of Artists' Writings* (Berkeley: University of California Press, 1996), p. 219.

3. "Joan Brady," *Artforum* (February 1991).

4. From the Painter'sKey.com.

5. Stephen Westfall, "Jane Wilson's Book of Days," *Art in America* (September 2007).

SUE SCOTT is an independent curator and writer who lives in New York City. She is co-author of the award-winning *After the Revolution; Women Who Transformed Contemporary Art* published by Prestel Publishing.

HOME

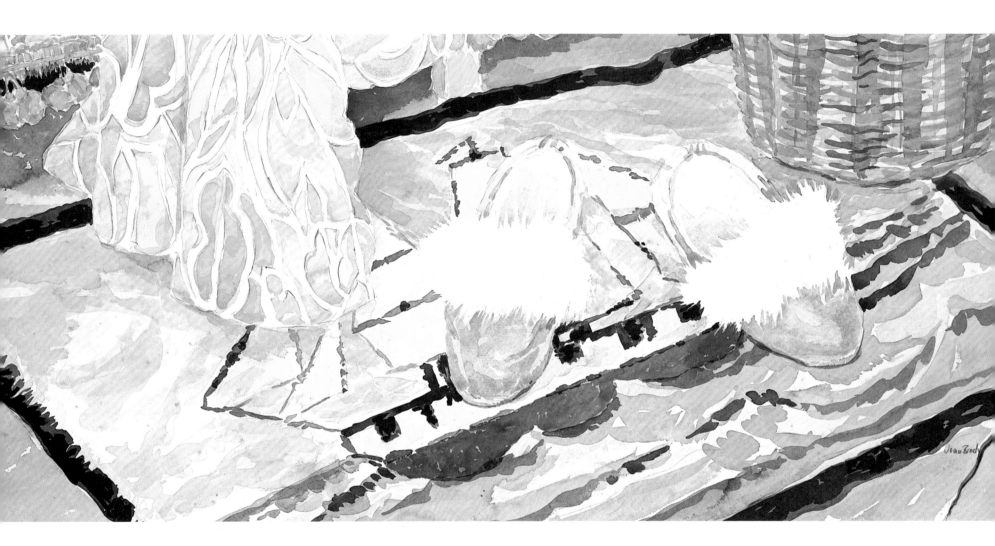

A woman's path need not always take her many miles from home.

It will, however, always invite her to let go of where she's already been,

& to open to the Mystery of where she's going.

SALLY LOWE WHITEHEAD

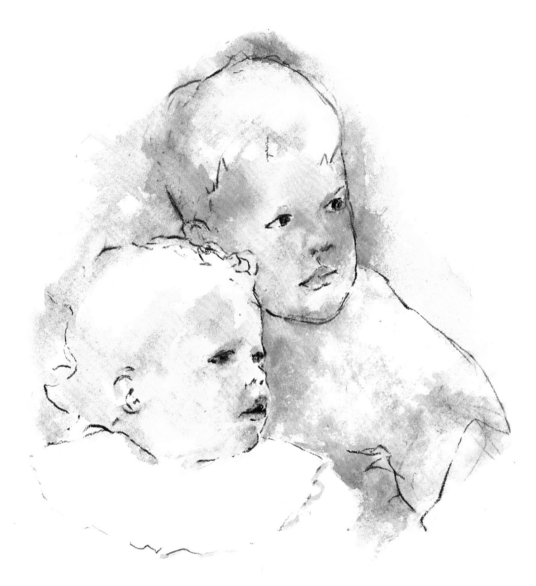

Jim and Nonie, 1962; Watercolor and charcoal on paper; 12 × 10 inches;
Collection of the artist

Tucking Him In

I remember one night, forty years ago,
snuggling him into his covers, my little blond boy,
our first-born child. Little Jim.
The magical age of six.

He held tight to Old Bowwow,
smells of sleep and awaking, cycles
of dirt, leftovers, and Ivory soap.
Very Old Bowwow, one tired tan ear.

Leaning over to kiss him goodnight,
my hair fell to his forehead,
my glasses nudged his face.
I pulled back and asked him,

"Do you love Mummy more
with her glasses on … or off?"
"On," he answered decidedly.
"Why?" I felt quite the reverse.

"Cuz when you have them on
means you're staying home,
and when you have them off,
you always go away."

First Watercolors

The art room, my haven through schools,
college, the Art Students League.
Always the place I felt most at home.
Most places I did not feel at home.

Classes in drawing, pastels, and oils.
Never in watercolor. No one to tell me
it was difficult, no room for mistakes . . .
for which I've been grateful ever since.

One day, in 1962, without aforethought
I bought my first set of watercolors,
a pad of paper, a brush, a pen. I began to play
with washes and color, charcoal and ink.

Divinely decided, I found my own way.
Through the years, my ways have changed.
And so have I . . .
beneath the brushstrokes.

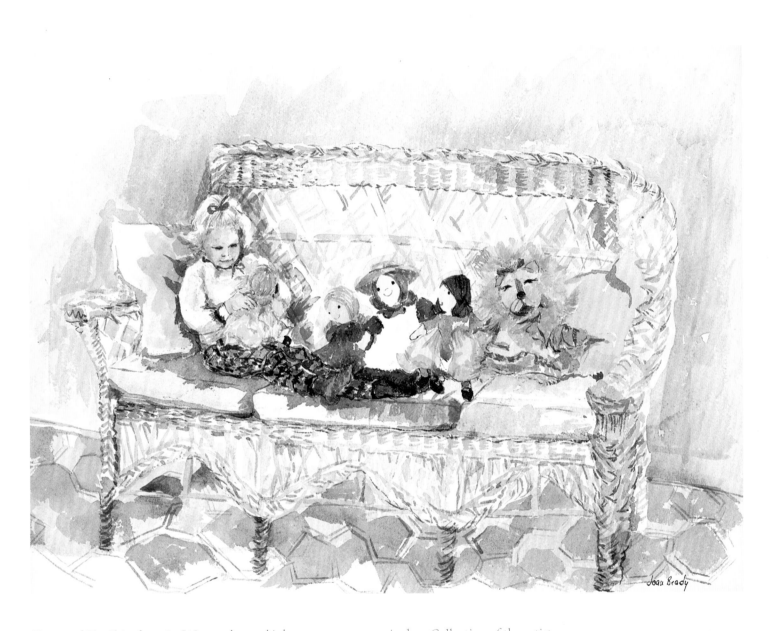

Kerry and Her Friends, 1969; Watercolor and ink on paper; 14 × 20 inches; Collection of the artist

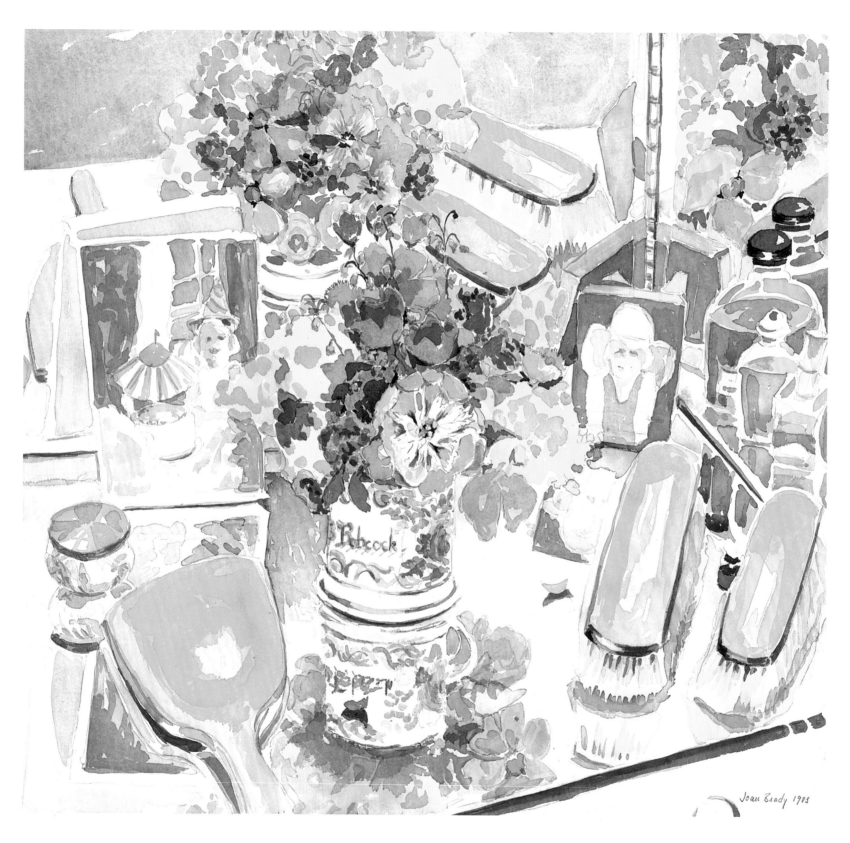

My Dressing Table, 1983; Watercolor on paper; 22 × 24 inches; Collection of the artist

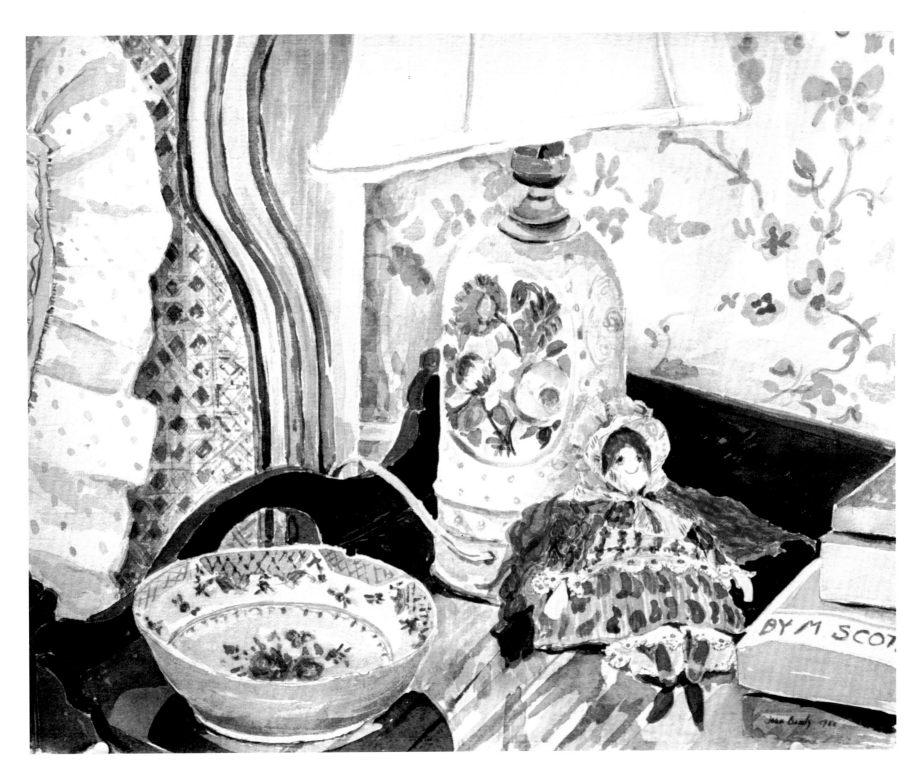

Bedside Table with Doll, 1982; Watercolor on paper; 18 × 22 inches; Collection of Vincent B. Murphy family

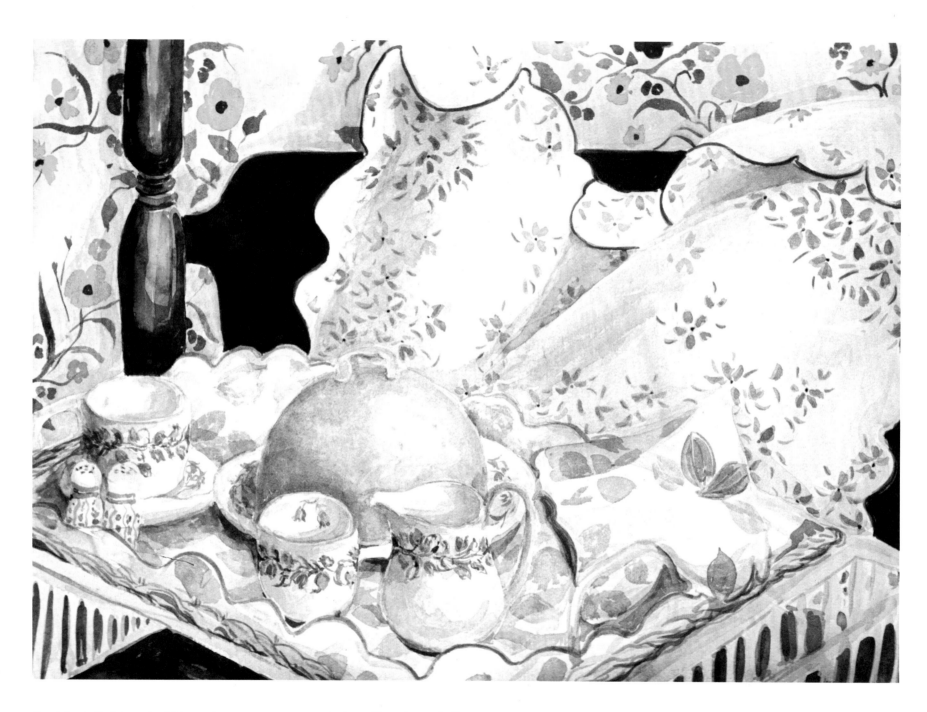

Breakfast in Bed #1, 1982; Watercolor on paper; 22 × 28 inches; Glenn Janss Collection

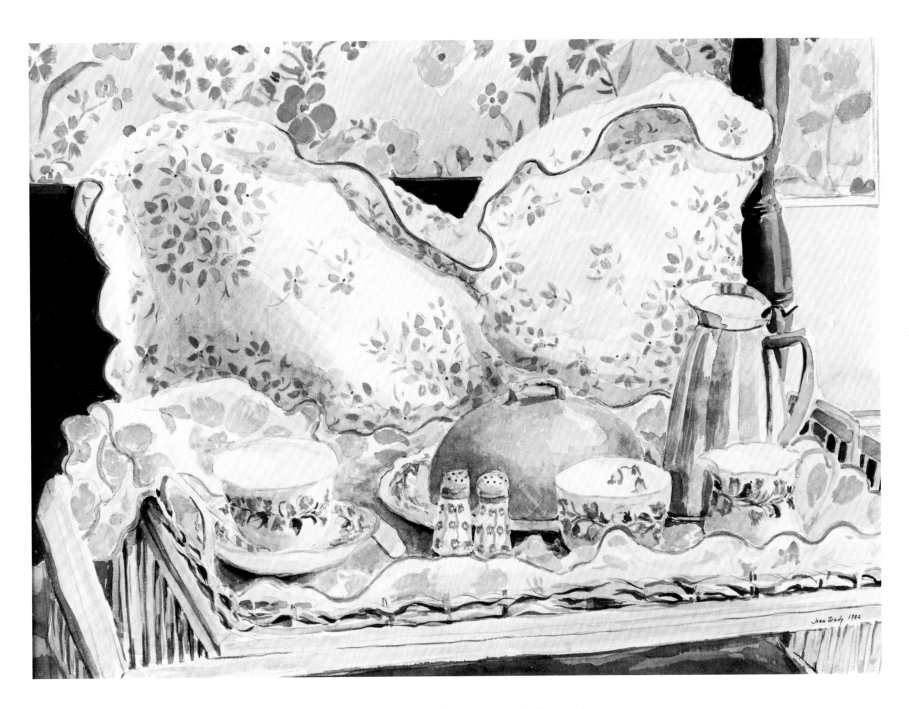

Breakfast in Bed #2, 1982; Watercolor on paper; 22 × 28 inches; Collection of Mr. and Mrs. Philip D. Allen

My Chair

Tonight, I look around my room and think how beautiful everything looks in the twilight. The color peach of the fading chintz on the armchair and ottoman. The embroidered pillow that Lisa gave me. Nestled into the pillows there, Mrs. Tiggywinkle, Paddington Bear with his red hat crooked on his head next to her.

I love the treasures I've collected, the way they look together, so many that end up in my paintings. The different colors in cranberry glass. The way the pale blue in the wallpaper and chintz sets off the peach. The flush of pleasure I feel, looking at, being surrounded by comforting colors. Arranging things on a table. A certain order inviting creativity.

Oh, that I could stay right here, centered in this soft-hued room, surrounded by books of wisdom, other keepers and teachers of my soul, while the world outside is swirling.

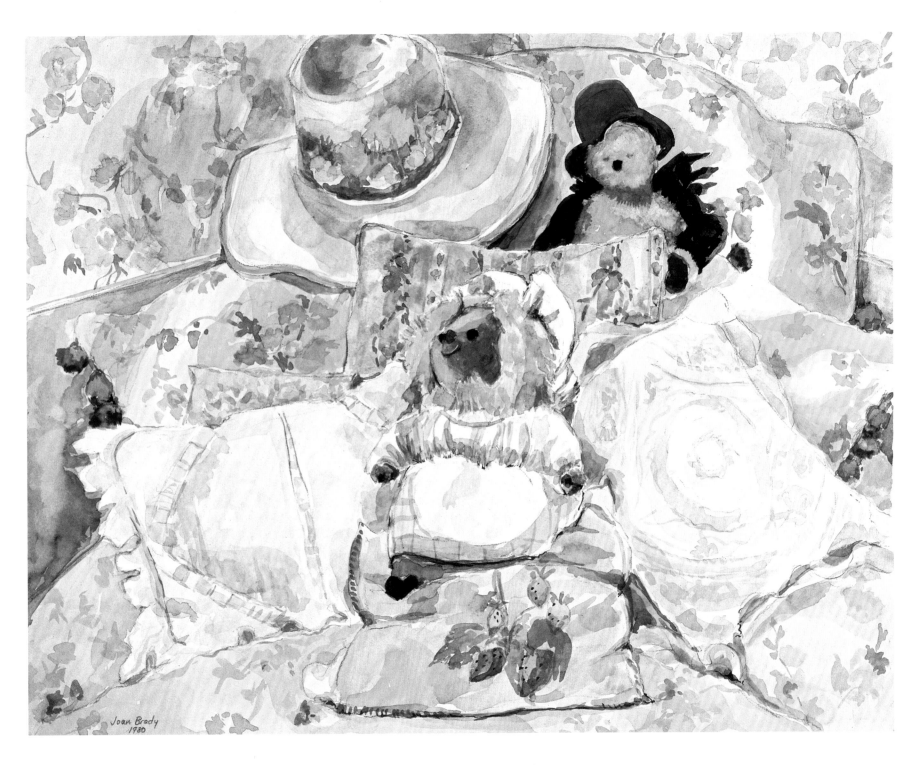

My Chair, 1980; Watercolor on paper; 16 × 20 inches; Collection of Mr. and Mrs. Philip D. Allen

Sketch of Jimmy in Library, 1991; Pen and ink in sketchbook; 10 × 8 inches; Artist's sketchbook

Wood Ducks

This morning, Jimmy called up the stairs to me, "Mum, come quick!"

I run down to the kitchen in my wrapper, to find Jimmy looking through binoculars out towards the river. He hands them to me and points to a mother wood duck and her fourteen newborns fanning out behind her and then forming a tight little "ship" to head straight over the waterfall. All within seconds.

As we watch in amazement, wondering how they will all make it through the turmoil of the falling water and the rapids below, the little ones reemerge, bouncing up and down in the white foam below the dam like ping-pong balls. Then, regrouping tightly around their mother, they float downstream. All fourteen of them, we count. Spreading apart now, they follow their mum on down the river, 'round the bend, and away to wherever they are headed, out of our sight.

Sketch of Jimmy's Head, 1991; Pen and ink in sketchbook; 10 × 8 inches; Artist's sketchbook

Jimmy marvels, "This happens one day out of the entire year and we are fortunate enough to witness it."

We remember, then, that we had actually watched the same scenario on another early morning about two years ago.

Just the other day, he showed me a mother merganser, cuddled on the dry overflow dam in the sun. A yard or so to her left, seven young mergansers huddled, pressed together in a row, heads turning right and left, pecking at each other.

If he wasn't here, I probably wouldn't even see the birds! He brings to me the wonders of the natural world in which he is the most comfortable.

Lemon Glass

"Lemon glass," collected
by his mother now gone,
holds memories, her messages,
our daffodils, combined.

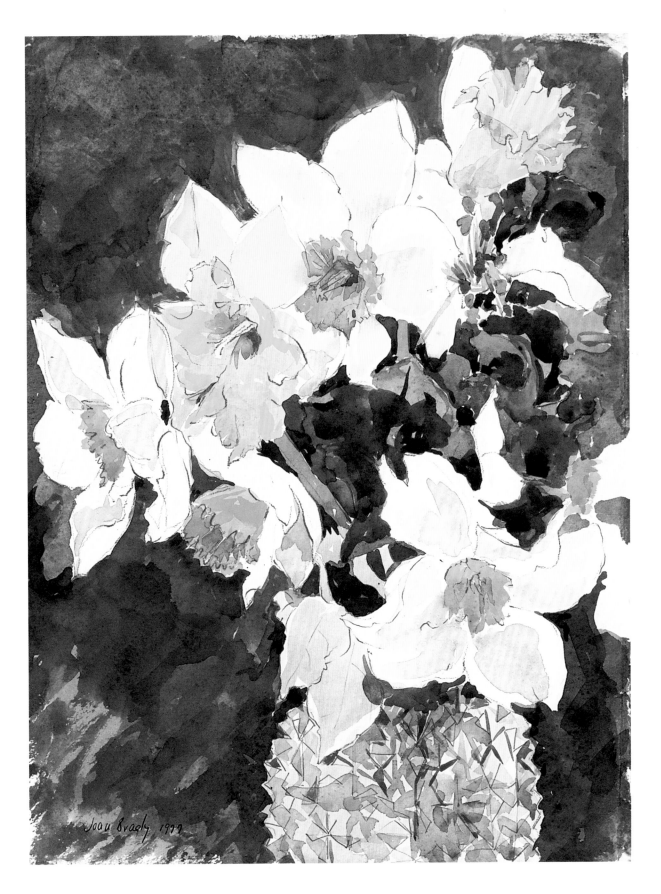

Lemon Glass and Daffodils, 1975; Watercolor on paper; 14¼ × 11 inches; Collection of the artist

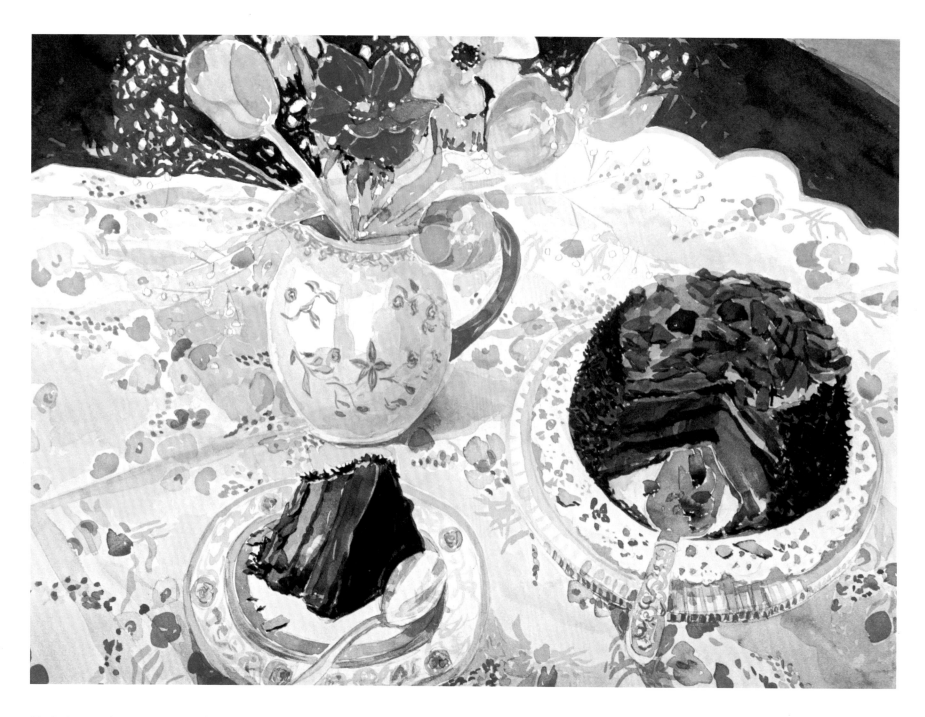

Black Forest Cake, 1984; Watercolor on paper; 22 × 30 inches; Collection of Crum and Forster

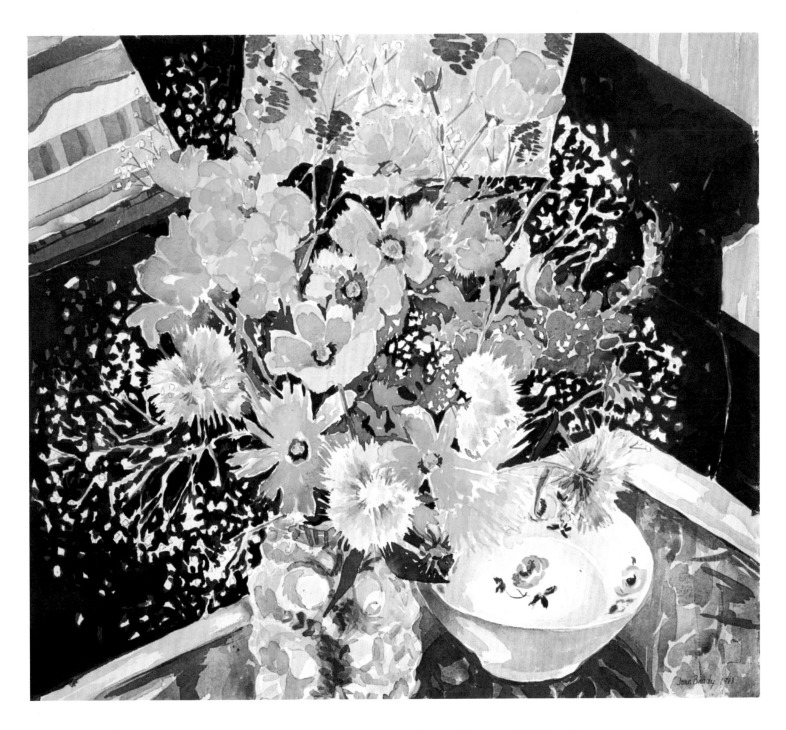

July Bouquet, Green Sofa, 1983; Watercolor on paper; 22 × 25 inches; Collection of Jane and Bob Carroll

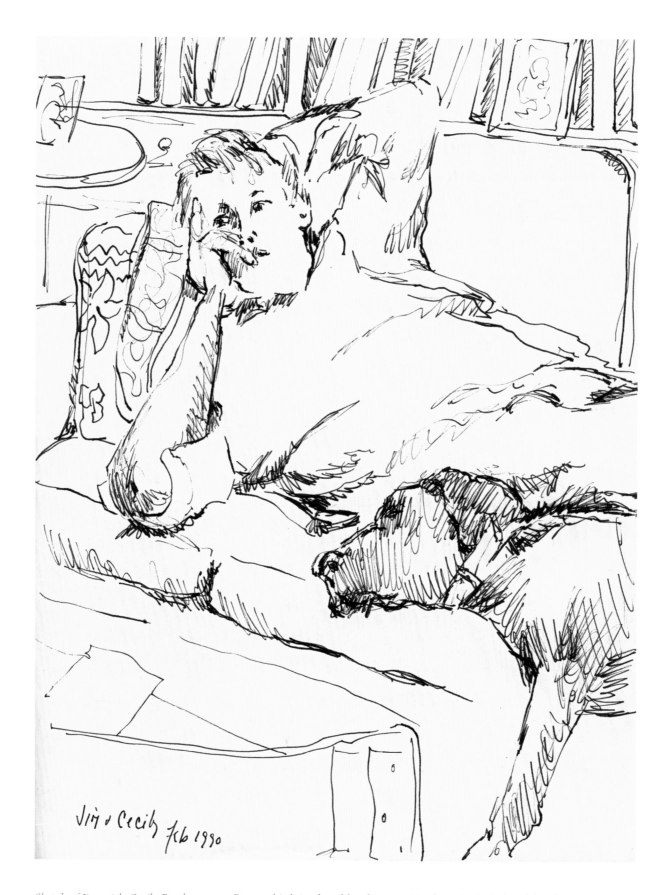

Sketch of Jim with Cecily Parsley, 1990; Pen and ink in sketchbook; 10 × 8 inches; Artist's sketchbook

Initiation, 1987; Watercolor on paper; 22 × 29 inches; Collection of Nonie and Wilhelm Merck

Fuzzy Slippers

Slipping … sliding … into sadness again,
vigilance betrayed by a single glass of wine
and severed communication
during dinner at the kitchen table.

Shoulders fallen, fuzzy slippered feet
shuffling back towards the fire,
where, just hours ago, I extolled the fullness
of life's mysteries with my friend.

Now, I stare into the orange embers
seething under the gray-white ashes.
And I wonder how it can happen
that my own flame sputters so easily.

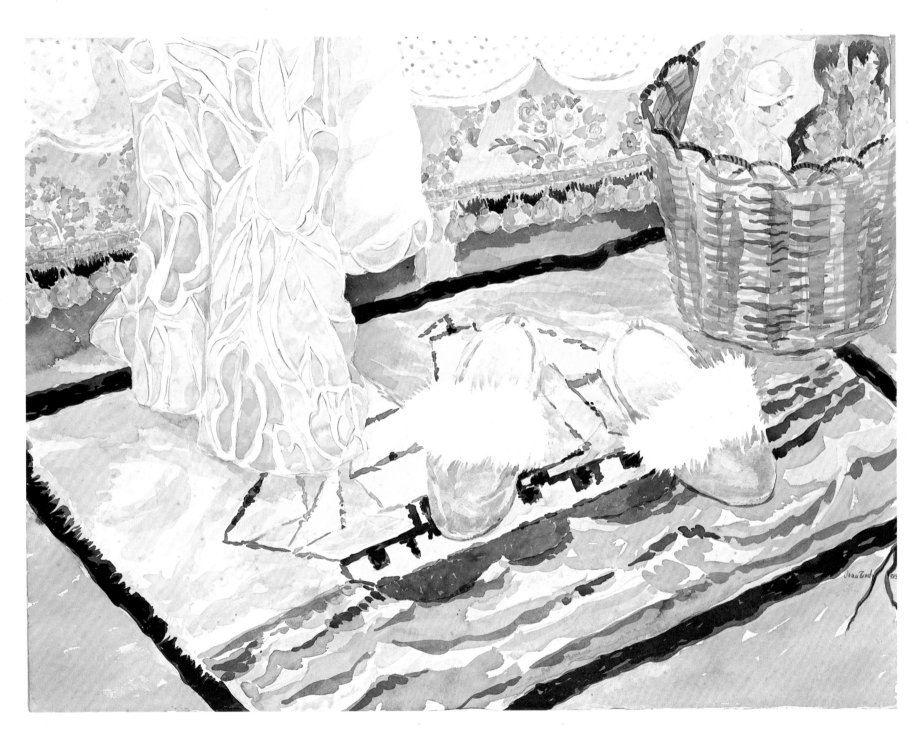

New Slippers on a Hooked Rug, 1985; Watercolor on paper; 22 × 30 inches; Collection of the artist

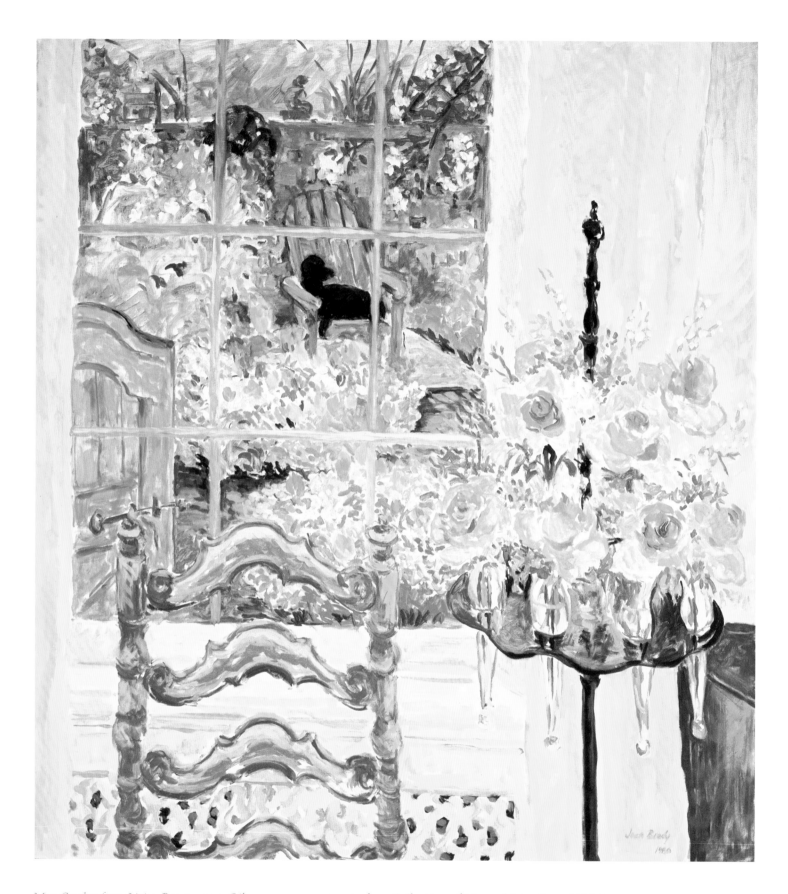

May Garden from Living Room, 1990; Oil on canvas; 30 × 24 inches; Collection of Mr. and Mrs. Peter W. May

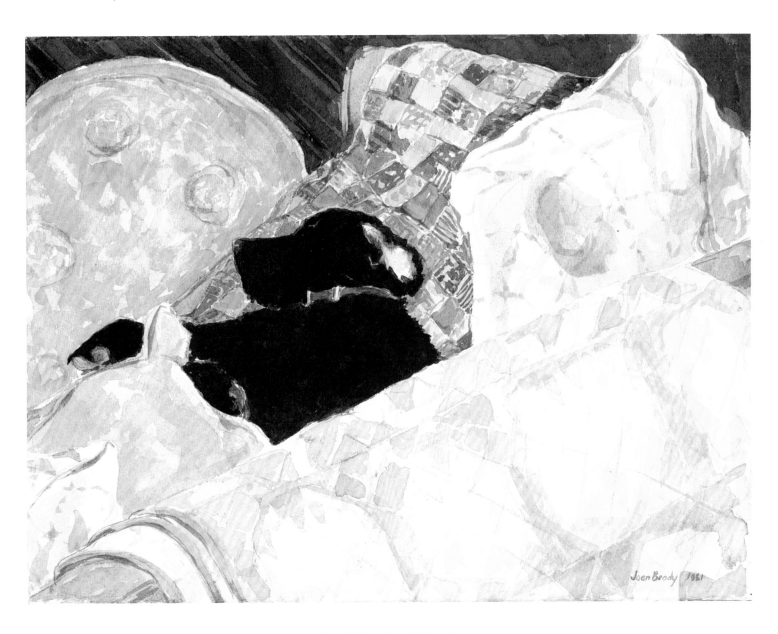

Puppy in Quilts, 1981; Watercolor on paper; 11 × 14 inches; Collection of the artist

Cooking with Teilhard de Chardin

Tonight in the kitchen, waiting for Jimmy to come home, I began Annie Dillard's new book, *For the Time Being,* and came upon these words by Père Teilhard de Chardin:

"Throughout my whole life, during every minute of it, the world has been gradually lighting up and blazing before my eyes until it has come to surround me, entirely lit up from within."

I remember, in 1973, when a book by Teilhard de Chardin jumped into my hands in a bookstore. I had never heard of him. I took it home.

A part of me, the part that hated school, didn't understand a word he was saying.

Another part, on some cellular level, knew exactly what he was writing about.

> No one to talk to,
> no teachers, no road maps.
> We follow the thread
> through thickets and thinnings.
> Watching for signposts,
> half lost in the dark.

Then, it began. An unending stream of books found me, leading me from one mystical tradition to another … and another … and, still, another.

> Like a dog with a bone …
> Am I the dog or the bone?
> "The Hound of Heaven"*
> Won't leave me alone!

And, finally, opening the inner door back to that place of Direct Connection which I had known when I was small. And then, forgot.

The Hound of Heaven by Francis Thompson

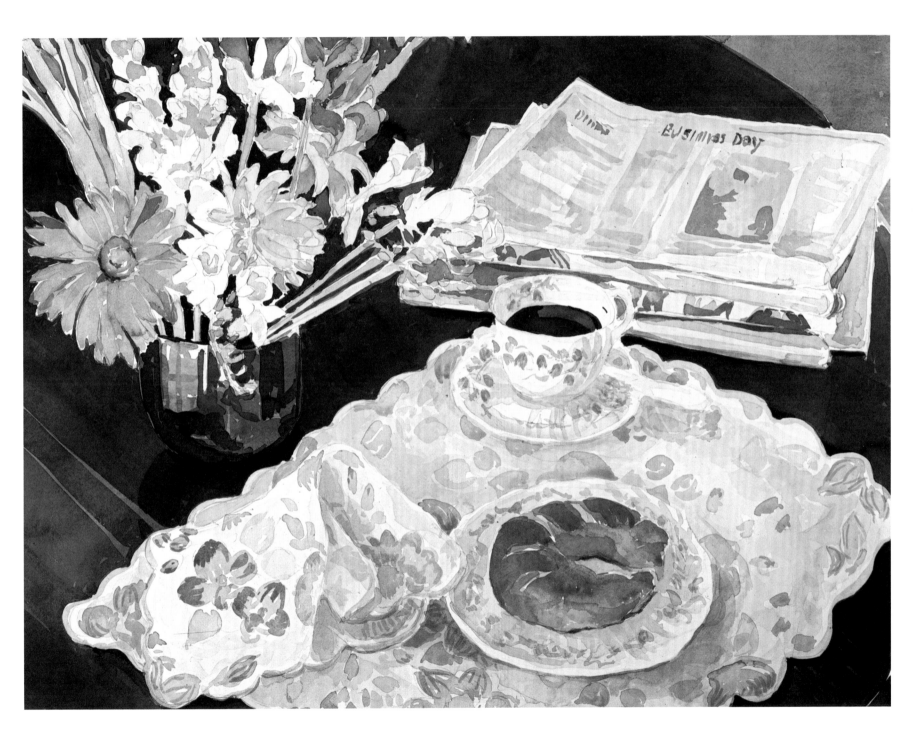

Sunday Breakfast with Croissant, 1984; Watercolor on paper; 22 × 30 inches; Collection of Brooke Stoddard

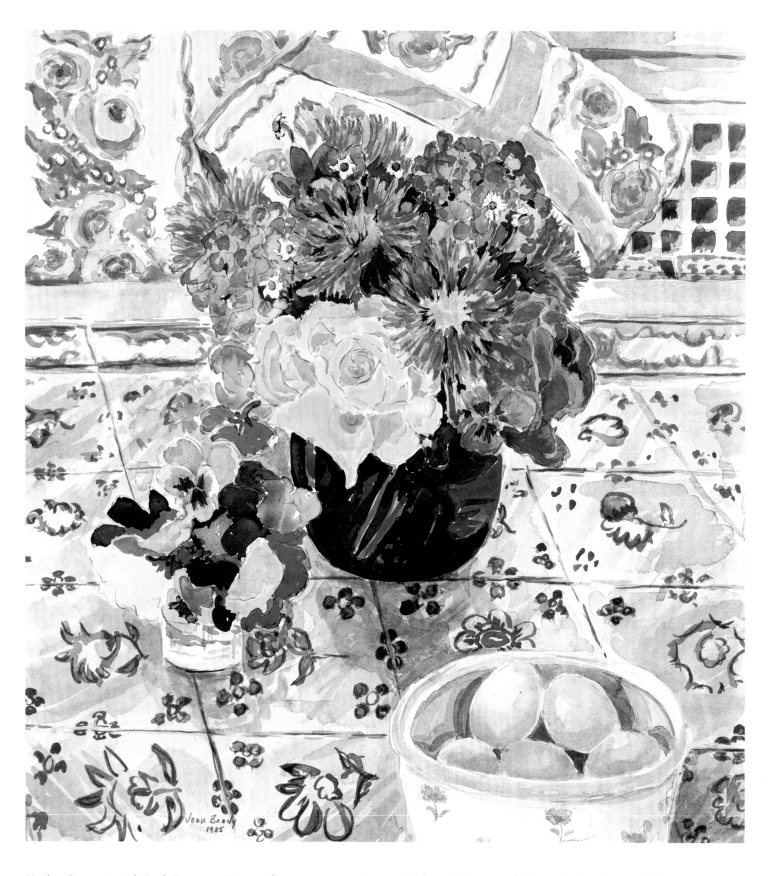

Kitchen Bouquets with Fresh Egg, 1985; Watercolor on paper; 20½ × 22½ inches; Collection of Mr. and Mrs. Charles E. Hance

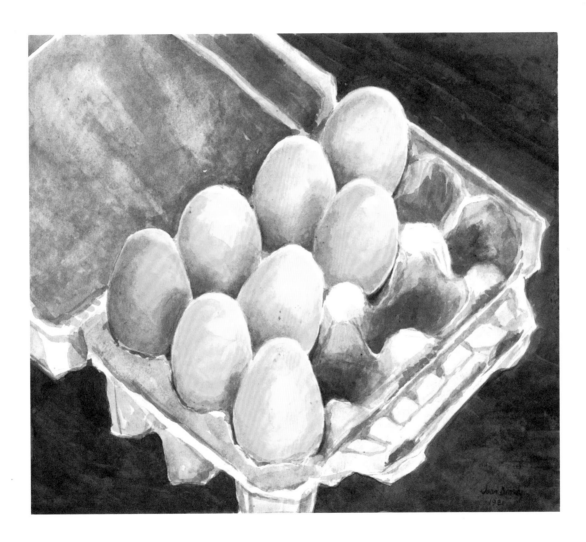

Eggs, 1981; Watercolor on paper; 9¼ × 10½ inches; Collection of the artist

Ratatouille

I remember …

Choosing eggplant, tomatoes, leeks, at the Farmers' market.

Bringing them home.

Setting them out on the kitchen table on a dish towel.

Painting a watercolor of the still life.

Cooking the vegetables in a heavy pot with olive oil, a little water,
seasoning, simmering, tasting …

Eating ratatouille for dinner with Jimmy by candlelight.

Framing the painting, naming it *Ratatouille* for a show,
where it was bought, and taken to its new home.

All of a piece. Epiphany.

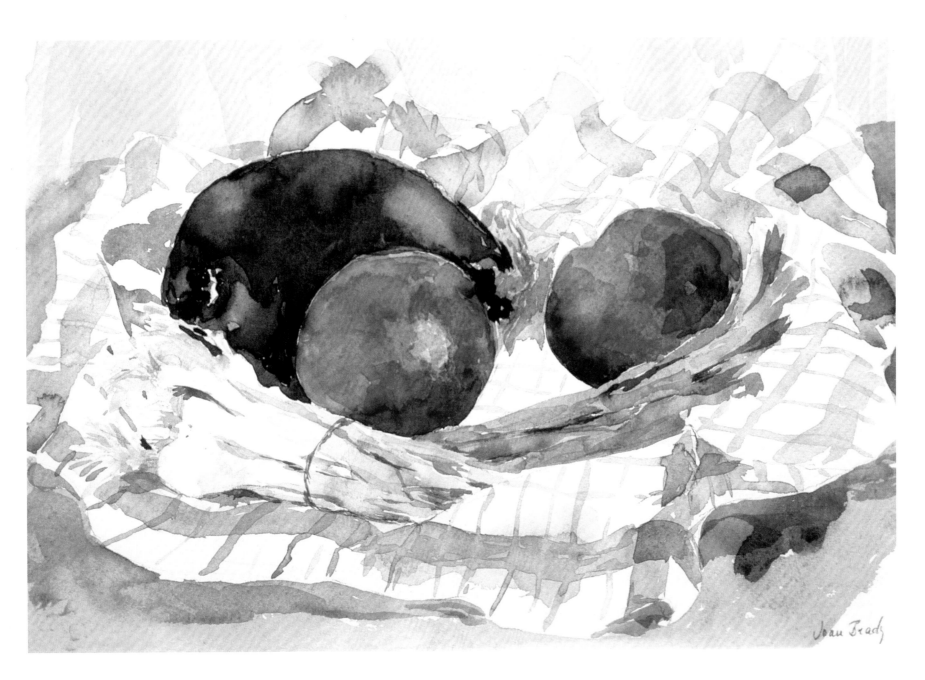

Ratatouille, 1977; Watercolor on paper; 11 × 14 inches; Collection of Mrs. B. Rionda Braga

Losing Track of Time

What is it you're doing
when you lose track of time?
When nothing hurts or bothers you?
All of a piece. Deep peace.

When I'm immersed in painting,
my brain goes on hold.
Somewhere out of this world,
I am part of the Universe.

Yes, it happens when I'm painting,
ballroom dancing too.
Often in my garden, in the kitchen,
mostly at home. My Home.

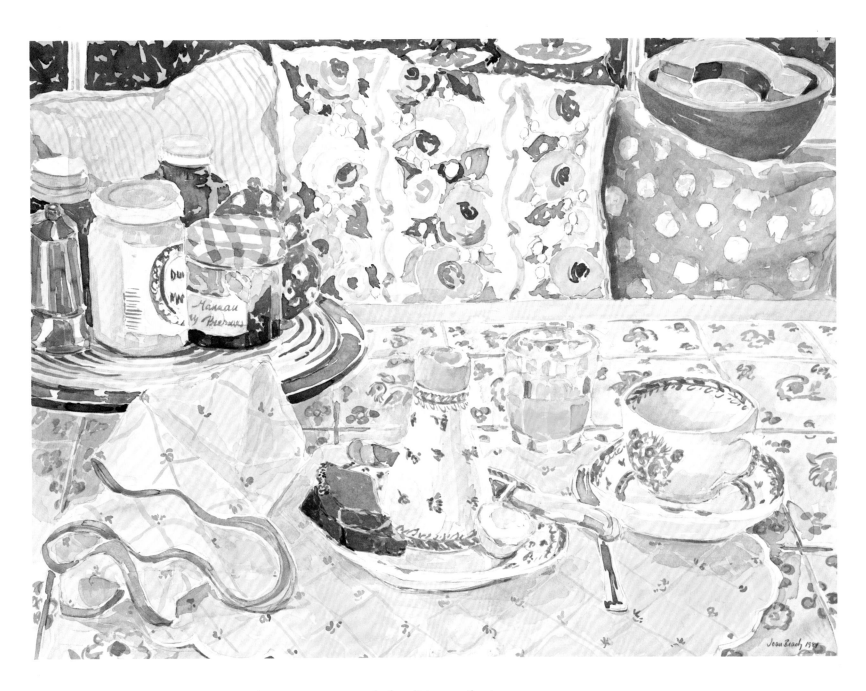

Soft-Boiled Egg, Lazy Susan, 1984; Watercolor on paper; 22 × 30 inches; Private collection

Audrey Slade Brady

A miracle. Our first grandchild, born on my birthday!
Her middle name, my mother's maiden name.

I knew immediately that she was the unknown gift
of joy that Mummy had promised me before she died.

When I push Audrey in her carriage, I watch her
looking overhead at the passing trees, perhaps beyond.

She travels somewhere else, sees something I cannot see.
Her look of bliss reminds me of Mummy's in her final days.

A Divine connection at the beginning and end of life.

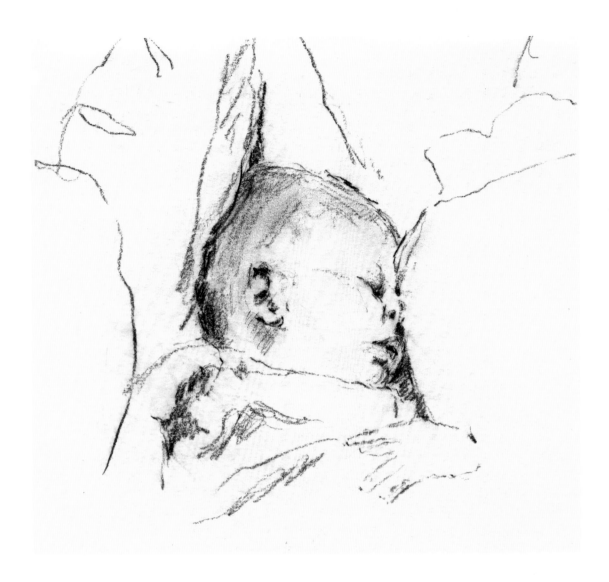

Sketch of Audrey as Baby, 1997; Sepia pencil on paper; Collection of the artist

Painting from Life

There's an intimacy that happens,
when painting directly from life.
An electric charge, a leap of faith
to sense the essence embodied
in a little face, a flower.

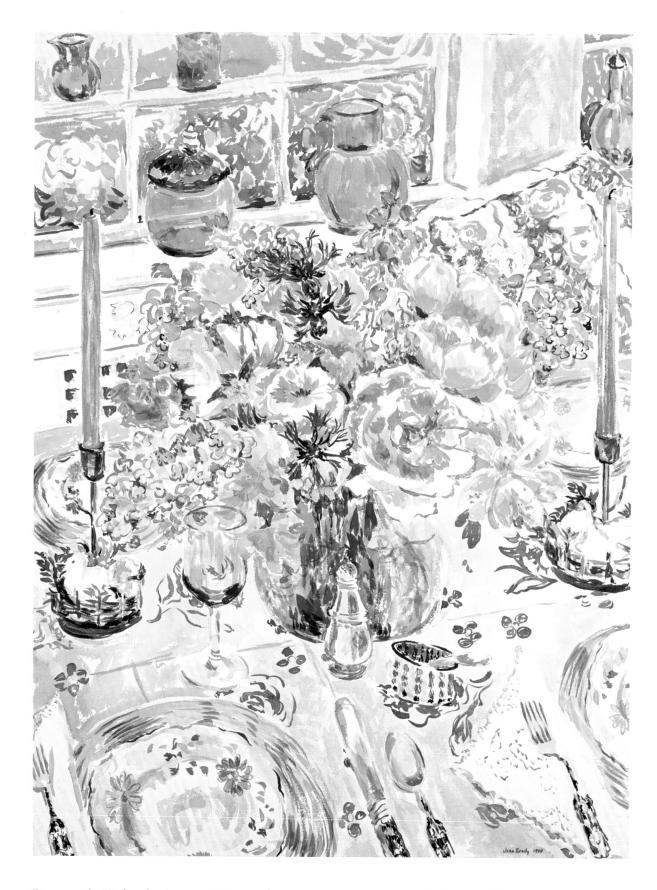

Dinner in the Kitchen for Four, 1998; Watercolor on paper; 40 × 30 inches; Collection of the artist

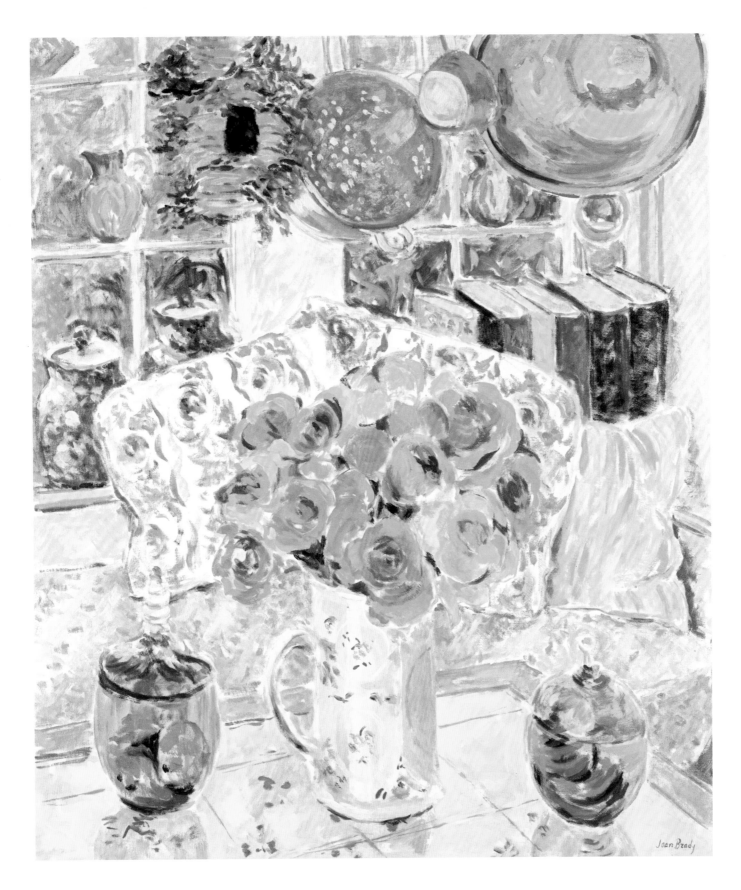

Kitchen Table, Bird House, Cookie Jar, 1991; Oil on canvas; 40 × 34 inches; Collection of the artist

The First of May

It's Saturday morning, the first of May… the day after our son Jim, Annie and their two little girls moved into the renovated cottage next door. Two days after Jim had taken his beloved eighteen-year-old male cat named Kitty to the vet to be put to sleep due to advancing cancer, kidney failure, and old age.

He called from their cottage to say that they were going to do the burial and asked if "Man," as our granddaughters call my husband, and I would like to join them.

Half an hour later, Jim arrived with his two small daughters carrying very big shovels. Audrey, almost seven, in a short skirt, long-sleeved shirt, and just below the knee rubber boots; Millicent, four years old, in a fairy princess costume… violet sateen with matching feathered cuffs and hem … and knee-high plastic boots. Perfect funeral attire!

We all headed across the lawn, over the bridge, past my studio, to the edge of the woods. After the girls settled on the gravesite, Jim began digging a deep hole back a little further into the woods behind where two of our Labradors, Blueberry and Cecily Parsley, are buried. We all agreed that Kitty liked out-of-the-way secret places.

Then, led by their grandfather, the girls waded in the stream next to the woods in their tall rubber boots picking up small and larger rocks to be put over the dirt on top of the grave to protect it from animal invaders.

Meanwhile, Jim walked back up to their house and returned, looking like a waiter, with a tray, something bulging on it covered by a towel … Kitty fresh out of the freezer.

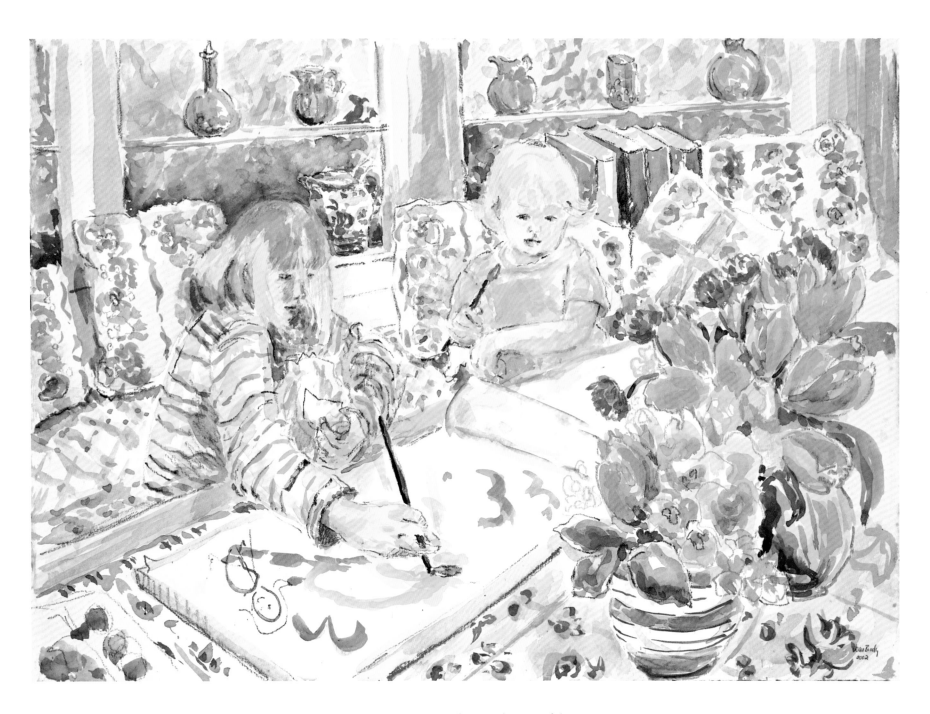

Audrey and Millicent Painting in Kitchen, 2003; Watercolor on paper; 30 × 22 inches; Collection of the artist

Marking Time

An undercurrent of quiet panic,
terror that I'm losing my grip.
A weakening bird in a golden cage.

I'm losing my nerve, my energy too.
Sometimes even my interest.
Not to mention my eyesight.

Have I built the cage myself?
Like the canaries in the coalmines.
No air. A slow and subtle death.

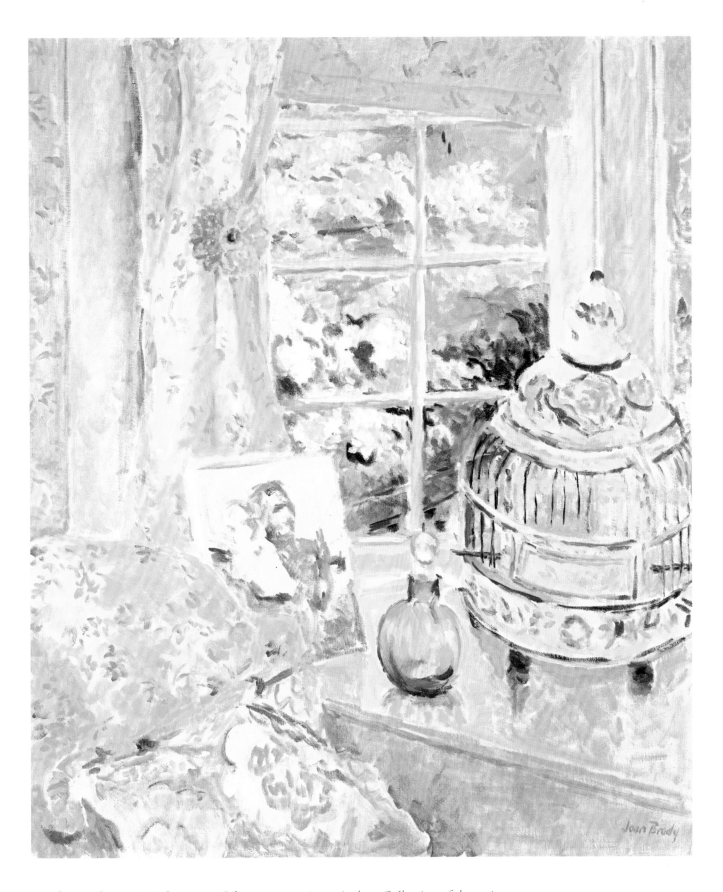

Porcelain Birdcage in Window, 1992; Oil on canvas; 36 × 30 inches; Collection of the artist

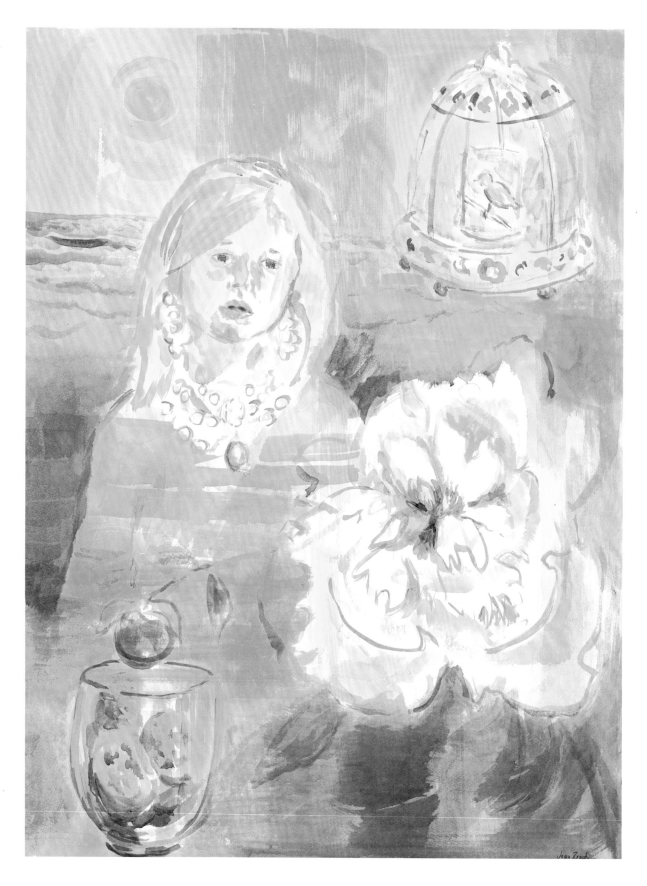

Millicent, Birdcage, Peony, 2006; Watercolor and acrylic on paper; Collection of the artist

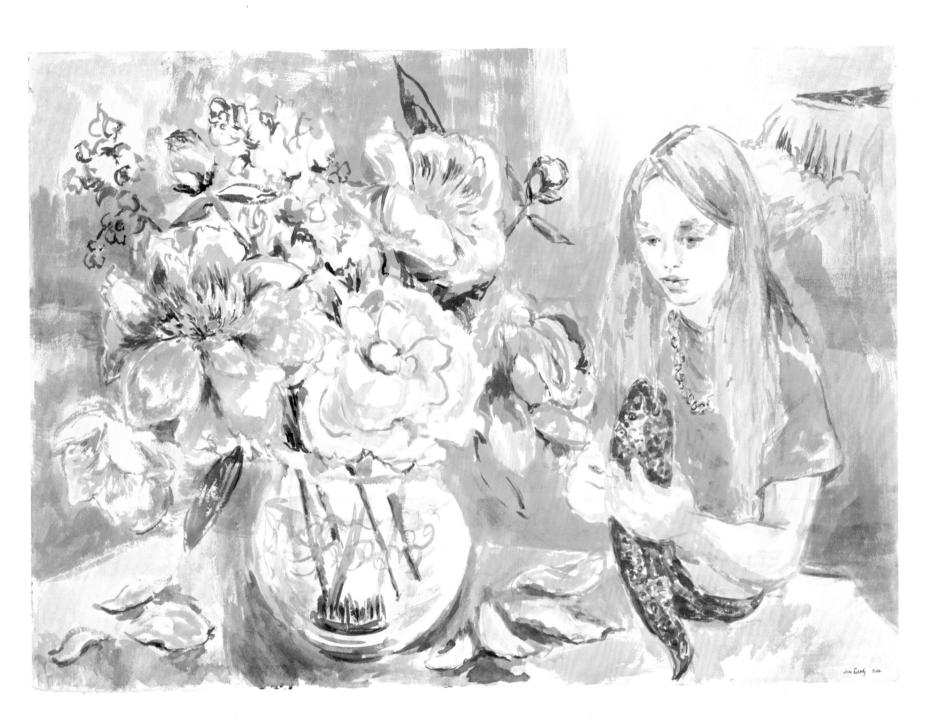

Audrey, Flowers, Fish, 2006; Watercolor and acrylic on paper; 30 × 40 inches; Collection of the artist

Eve's Dilemma

A choice between obedience and knowledge.

Between renunciation and appetite.

Between subordination and desire.

Between security and risk.

Between loyalty and self-development.

Between submission and power.

Between hunger as temptation and hunger as vision.

It is the dilemma of the modern woman.

KIM CHERNIN, *Reinventing Eve*

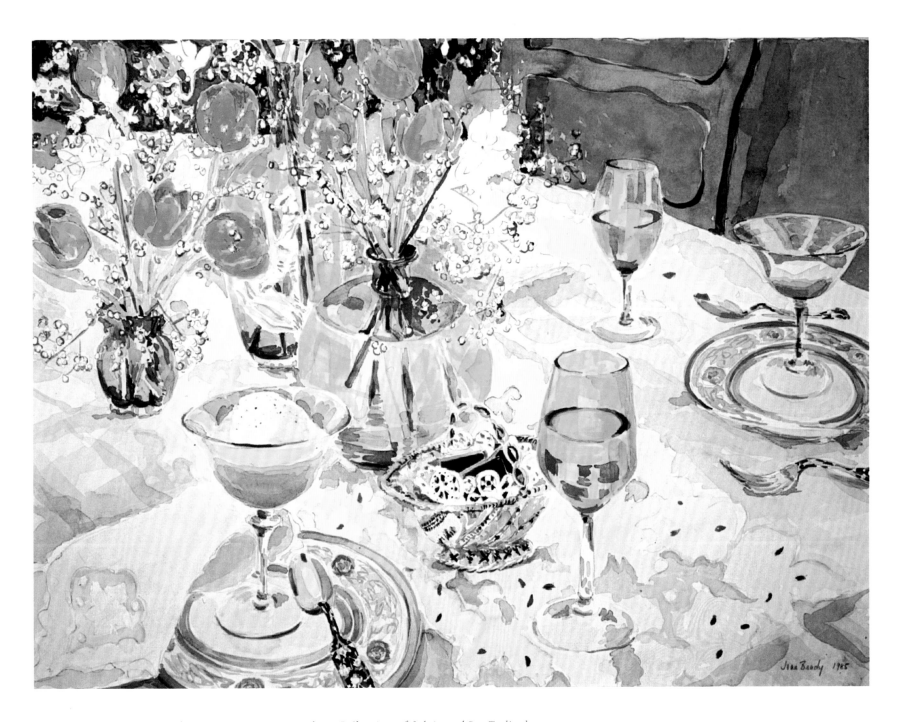

Just Desserts, 1985; Watercolor on paper; 22 × 30 inches; Collection of Sylvia and Joe Frelinghuysen

Around Christmas

Such happiness I feel just sitting across from our Christmas tree, looking at all the ornaments made over so many years. Noticing this year's combinations, remembering the different Decembers' hand-made creations.

Nonie's cotton-faced Santa, Jim's green sequined ball that he insists goes in its usual place towards the back of the tree. The paper angel Kerry made, Scotch-taped to the glass front door, peeks through the hole in the center of every year's wreath. She needs a bit of surgery to glue her wings back on.

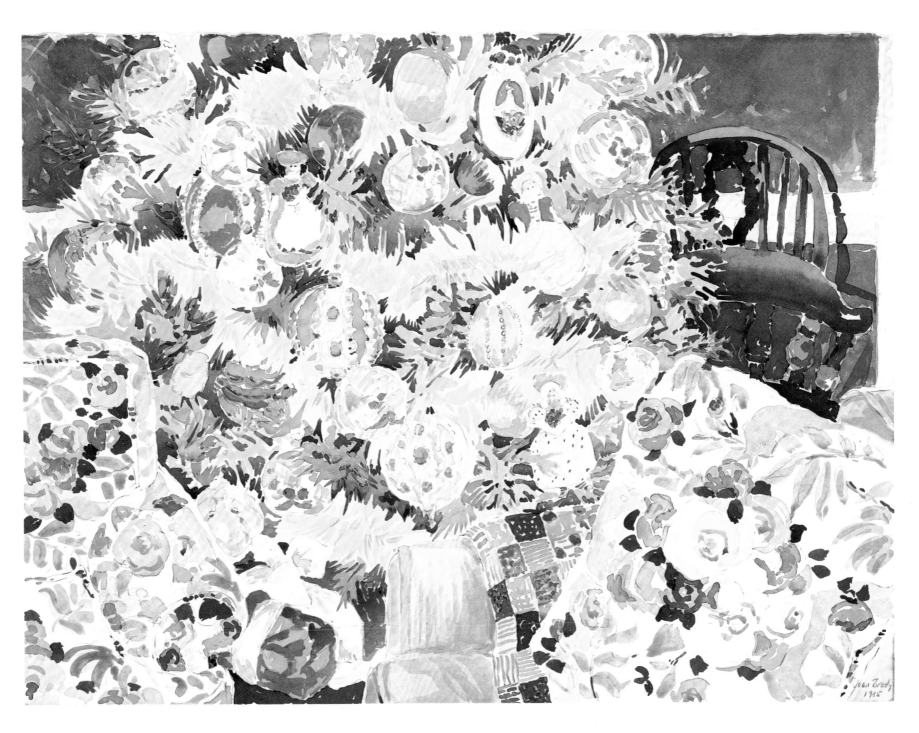

Next to the Christmas Tree, 1985; Watercolor on paper; 22½ × 30 inches; Collection of the artist

Her New Voice

She hears her new voice
come forth these days,
wise, surprising herself
in circles in which she sits.

Not the old social circles,
so like musical chairs,
losing her place, her voice,
feeling excluded, outside.

But with those who delve deeper.
She listens now and, when she speaks,
from a place so knowing,
she wonders whose voice she hears.

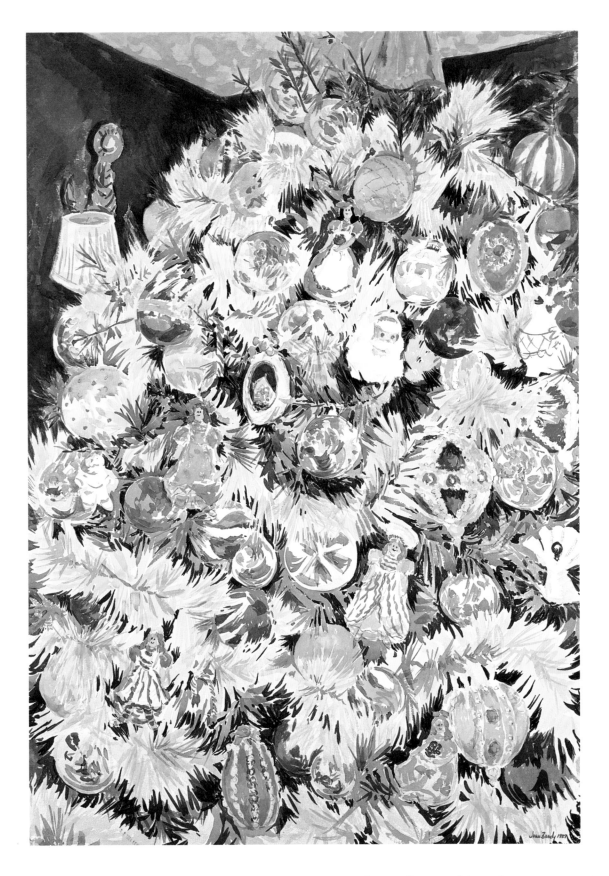

Full Christmas Tree, 1984; Watercolor on paper; 41¼ × 29⅛ inches; Collection of the artist

A Visit

At the desk in my office, writing,
answering letters about Mummy
a few weeks after she has gone.
Deep into memories, stories shared,

I feel her presence, look up and there,
between the window and the door,
she stands. All in white, shimmering light.
Auburn curls to her shoulders, her radiant smile.

Love pouring from her eyes over me,
saying everything without a word.
Through pounding heart, I understand …
Just love. And thank you too.

Then she was gone, but not away.

The Visit, 1994; Watercolor on paper; 20 × 14 inches; Collection of the artist

IN THE STUDIO

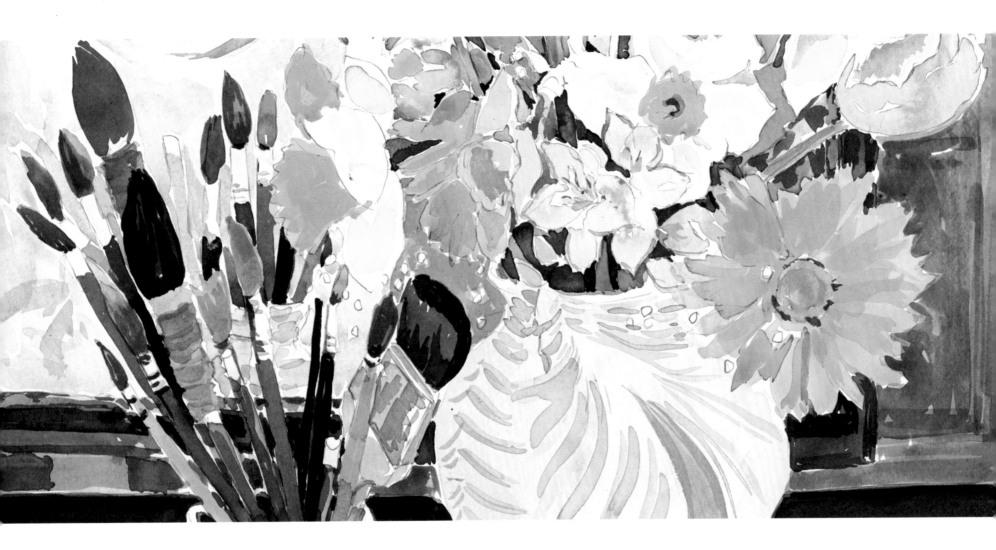

You know, you have one idea, you are born with it,

and all your life you develop your fixed idea,

you make it breathe.

HENRI MATISSE

My Studio

Illuminated by early morning light,
my studio across the river
calls to me.

Over the wooden bridge, I travel
through two hundred years
to today.

Wheels grinding, bridles jangling,
horse and buggies roll by
in my mind.

Open the door into paintings
tacked up on honey wood walls,
the easel set.

Once inside, the brush flows free.
But, too often I find other things
I "must" do.

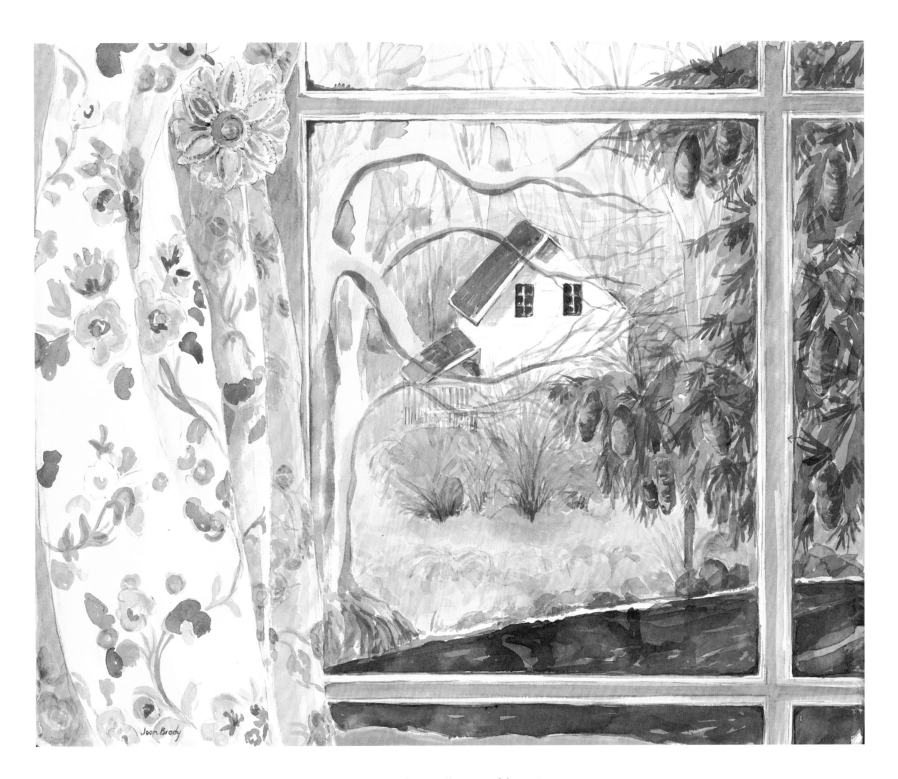

Studio from Bedroom Window, 1982; Watercolor on paper; 18 × 22 inches; Collection of the artist

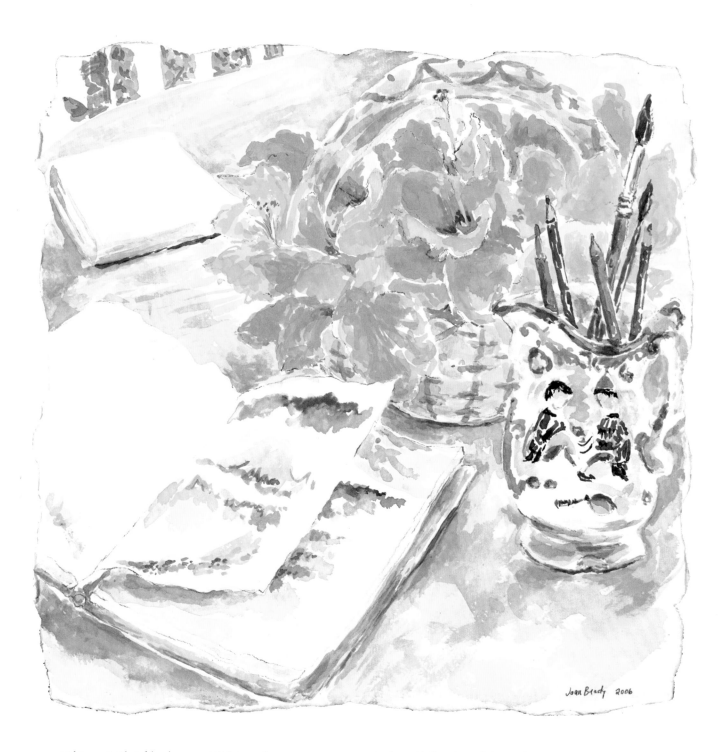

Hibiscus & Sketchbooks, 2006; Watercolor on paper; 15 × 15 inches; Collection of the artist

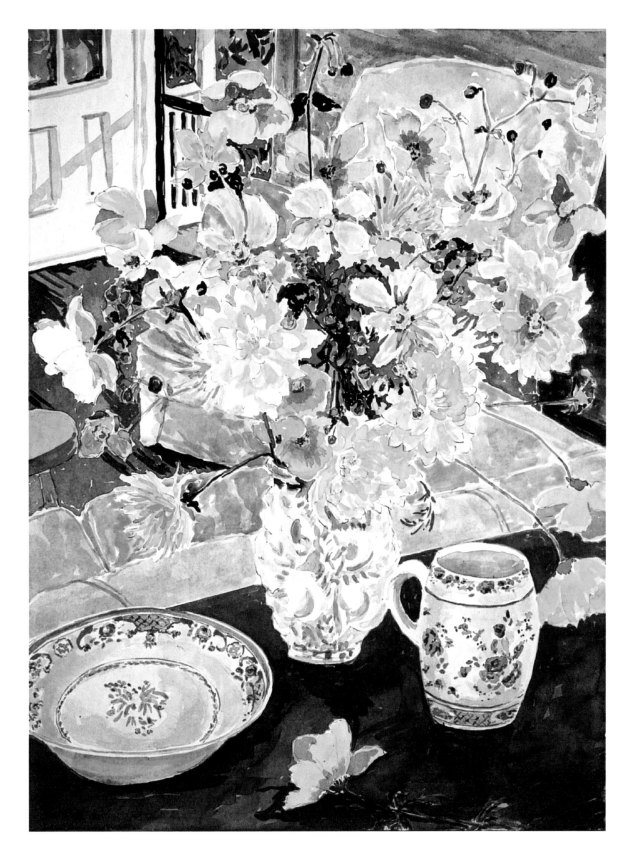

Dahlias, Japanese Anemones in Studio, 1985; Watercolor on paper; 30 × 22½ inches;
Collection of Mr. and Mrs. Henry L. Hillman

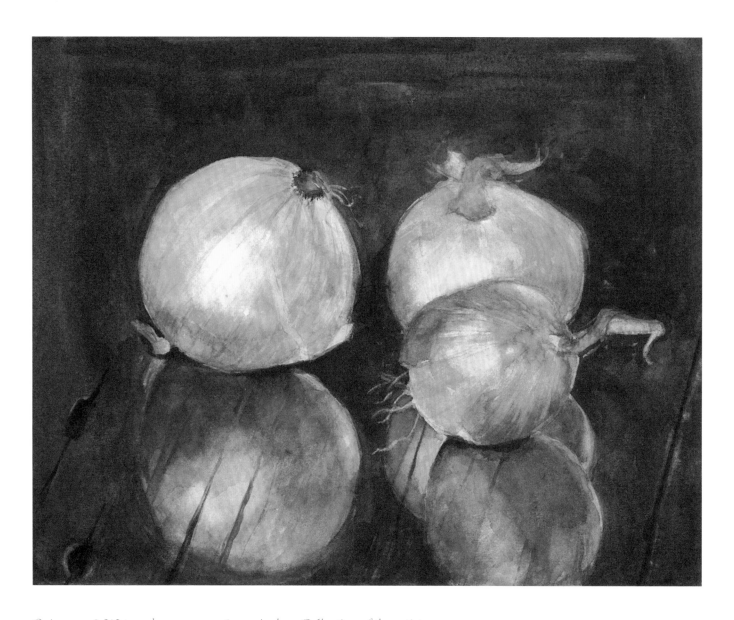

Onions, 1978; Watercolor on paper; 8 × 10 inches; Collection of the artist

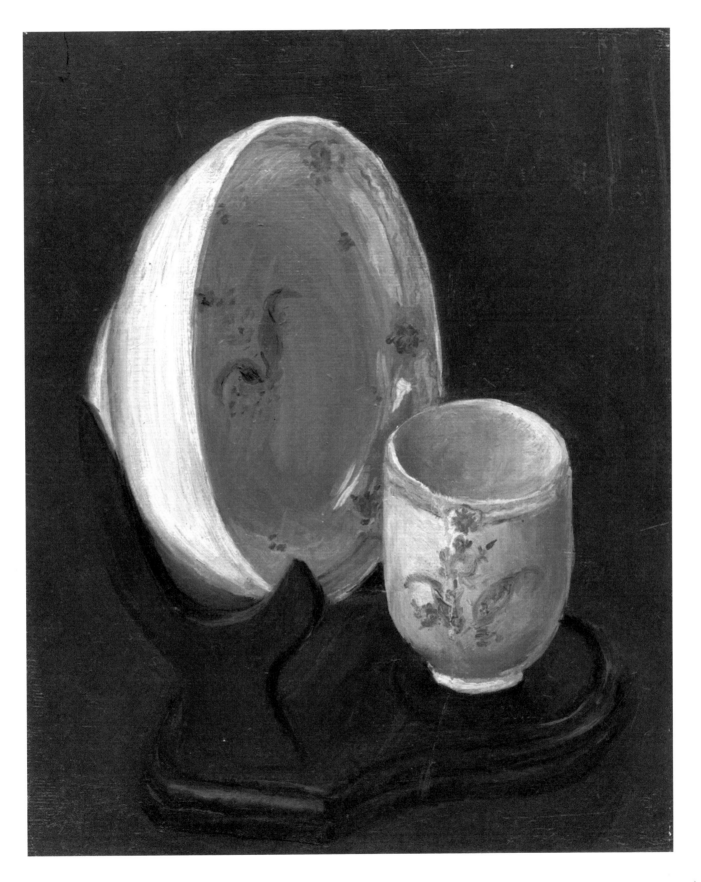

Cup and Saucer, 1988; Oil on canvas; 10 × 8 inches; Collection of the artist

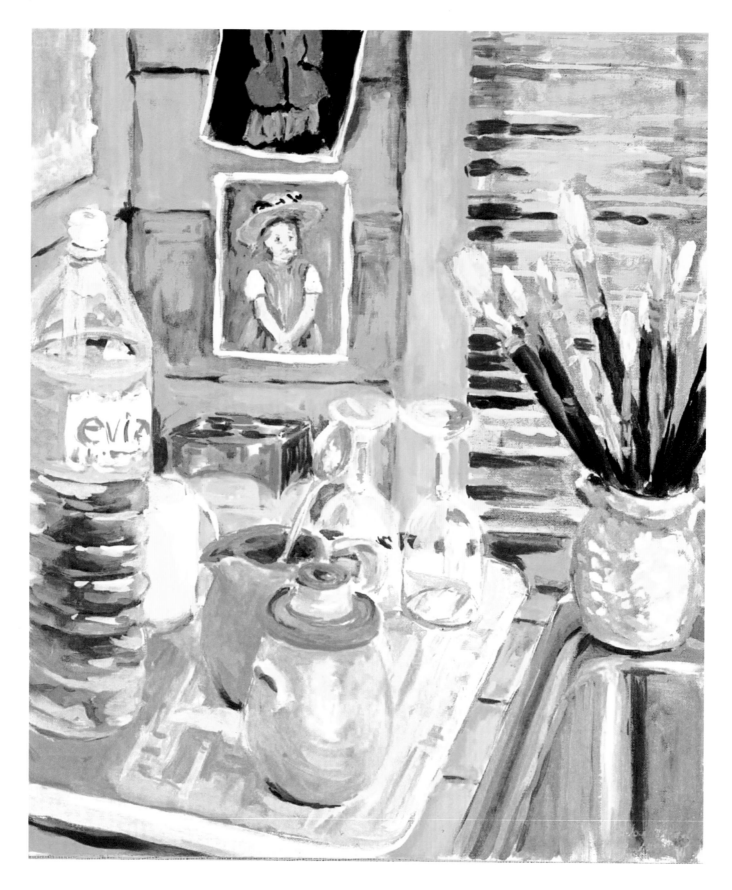

Next to the Studio Sink, 1990; Oil on canvas; 26 × 22 inches; Private collection

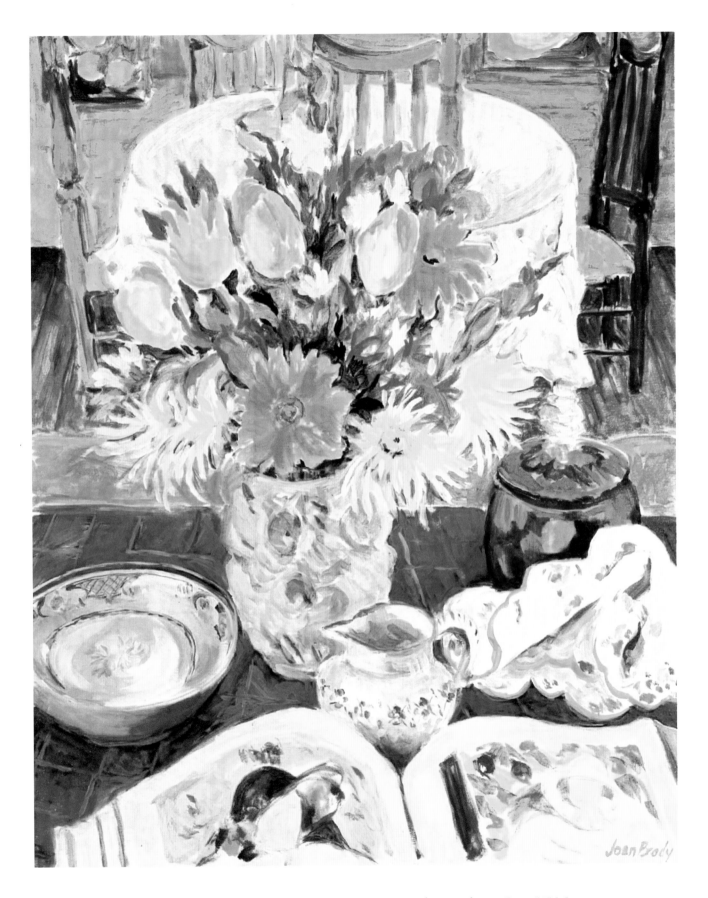

Afternoon in the Studio, 1988; Oil on canvas; 30 × 24 inches; Collection of Mr. and Mrs. Peter W. May

I Scared Myself

I scared myself
at first ...
after I was accepted
by the gallery in New York.

I was thrilled ... I'd made it.
Made what?
He'd taken some watercolors
to keep in a drawer in New York.

I went back to my studio to work.
I had taken my painting "out there"
somewhere. Out of the kitchen,
away from the ordinariness of my life.

Suddenly, it choked.
No oxygen, no fuel.
It shriveled up, I couldn't paint.
I'd scared myself to death.

Art doesn't work, separate like that,
disconnected, out of the pot.
I brought it home, stirred it back in
with everything else that was cooking.

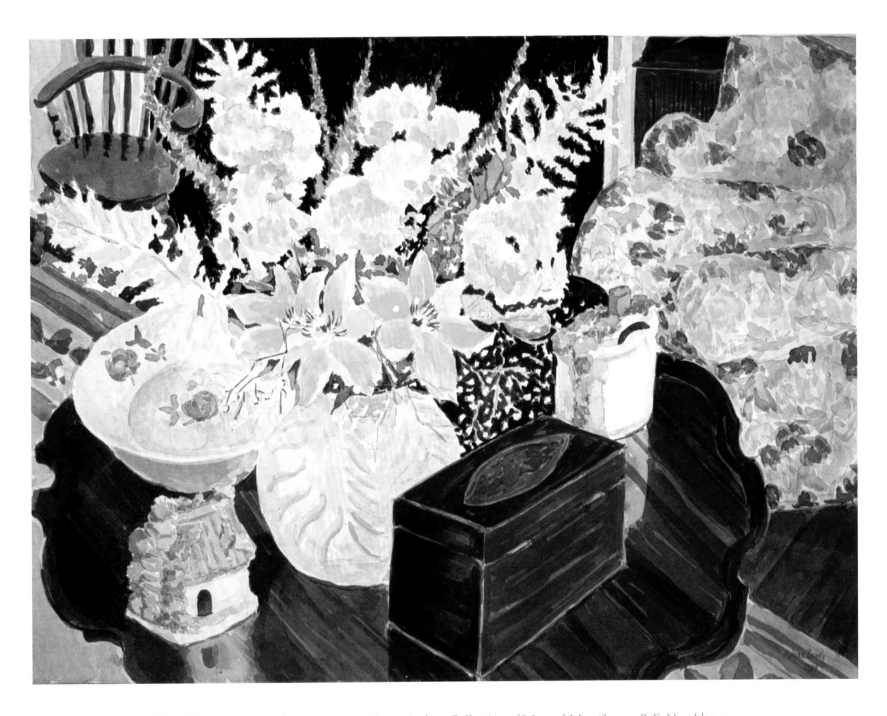

Favorites on a Chippendale Table, 1985; Watercolor on paper; 22½ × 30 inches; Collection of Mr. and Mrs. George B. E. Hambleton

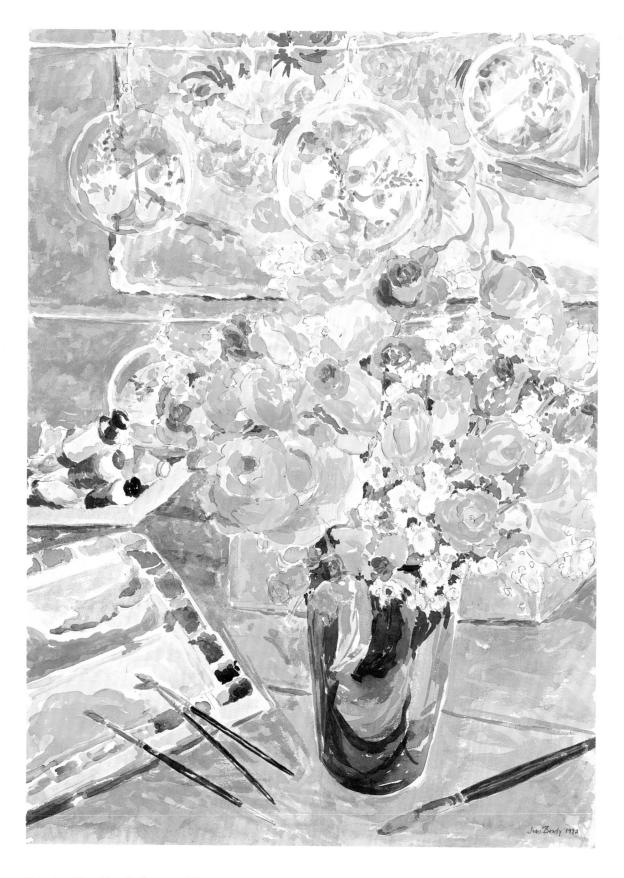

Painting Glass Tree Balls, 1992; Watercolor on paper; 30 × 22 inches; Collection of the artist

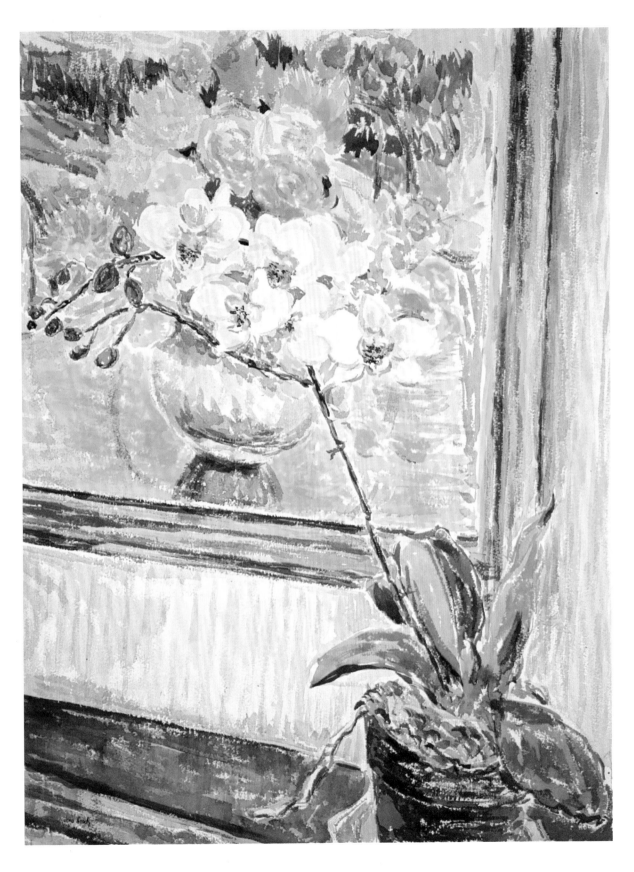

Orchid and Oil, 1998; Watercolor on paper; 30¼ × 22½ inches; Collection of Nonie and Wilhelm Merck

On Not Being Able to Paint

Can anyone who doesn't paint know the black gloom of this stage of starting over again? Out from the ashes of the last lump of painting time and the time in between. After the show comes down.

If Van Gogh cut off his ear, I could almost imagine, today, doing worse to myself to end this misery! With echoes of ladies' voices taunting, "Oh, you're so lucky to have your painting…"

I know that only another artist can understand the darker side of the picture. The total opposite of what hangs on the walls of a gallery show. And, such a short time later, to lose faith so fast, to be able to moan, with a tight lump in my throat, and murder in my eye, "Damn … I just can't do it!"

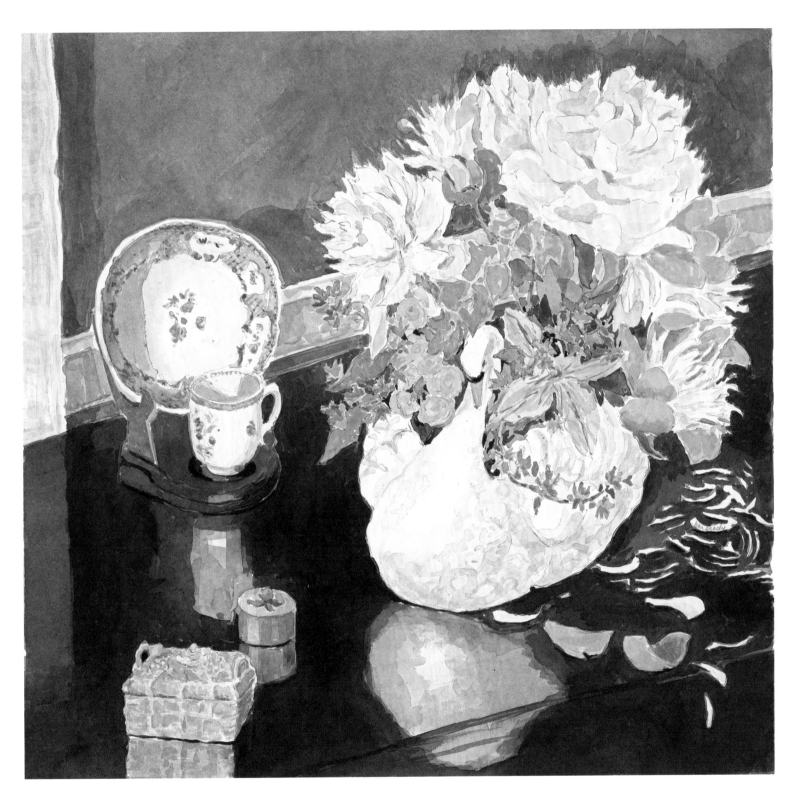

Porcelain Swan with Peonies, 1985; Watercolor on paper; 22½ × 22¼ inches; Collection of Mr. and Mrs. Philip D. Allen

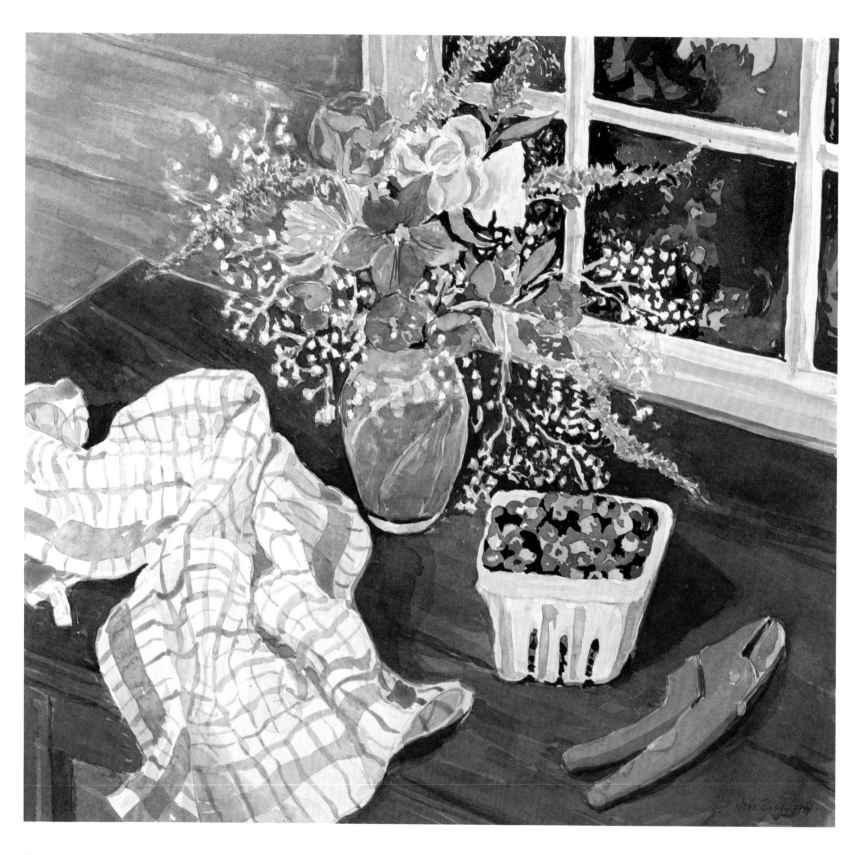

Blueberries in the Studio, 1984; Watercolor on paper; 22 × 22 inches; Collection of Howard Berkowitz

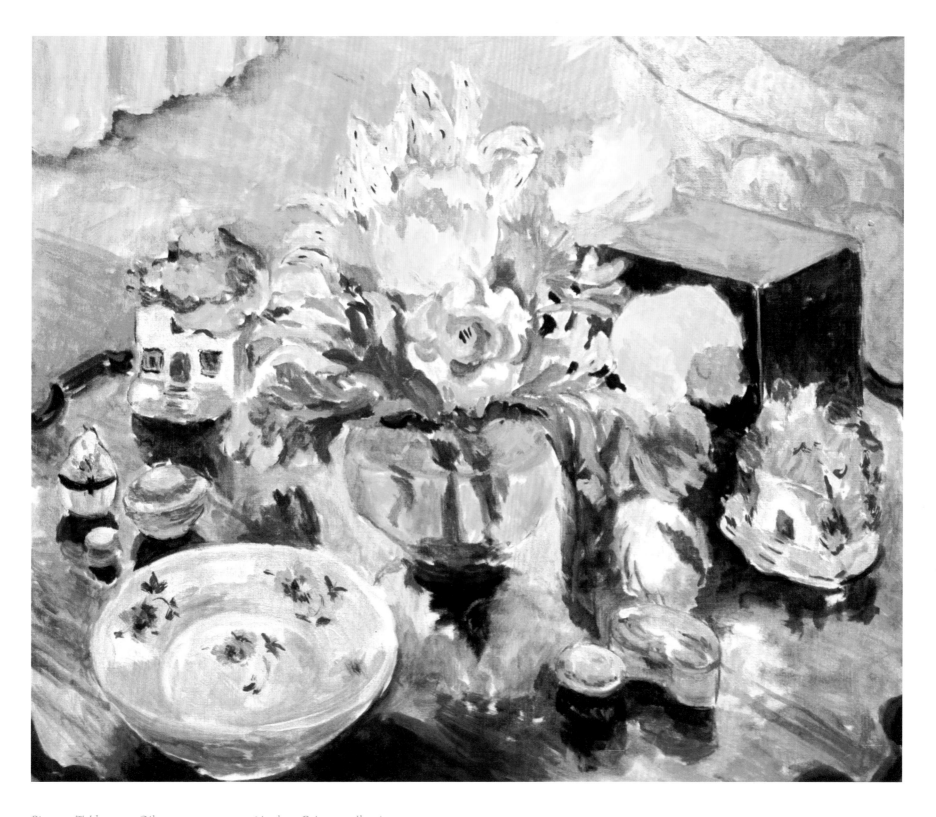

Piecrust Table, 1991; Oil on canvas; 34 × 36 inches; Private collection

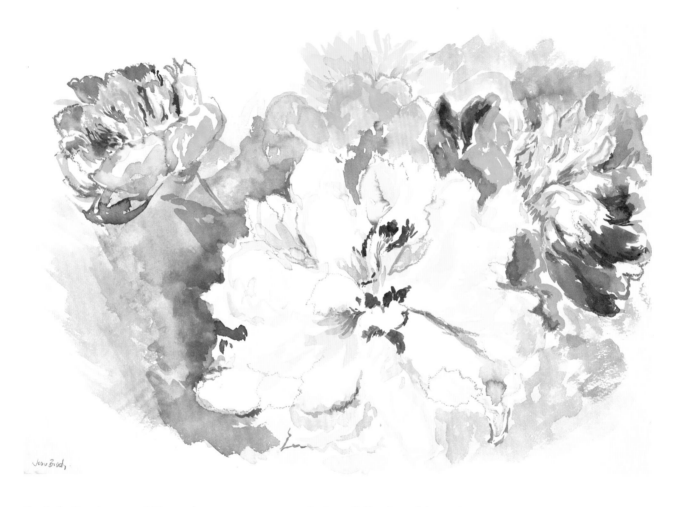

Study for Peonies, 1999; Watercolor on paper; 20 × 14 inches; Collection of the artist

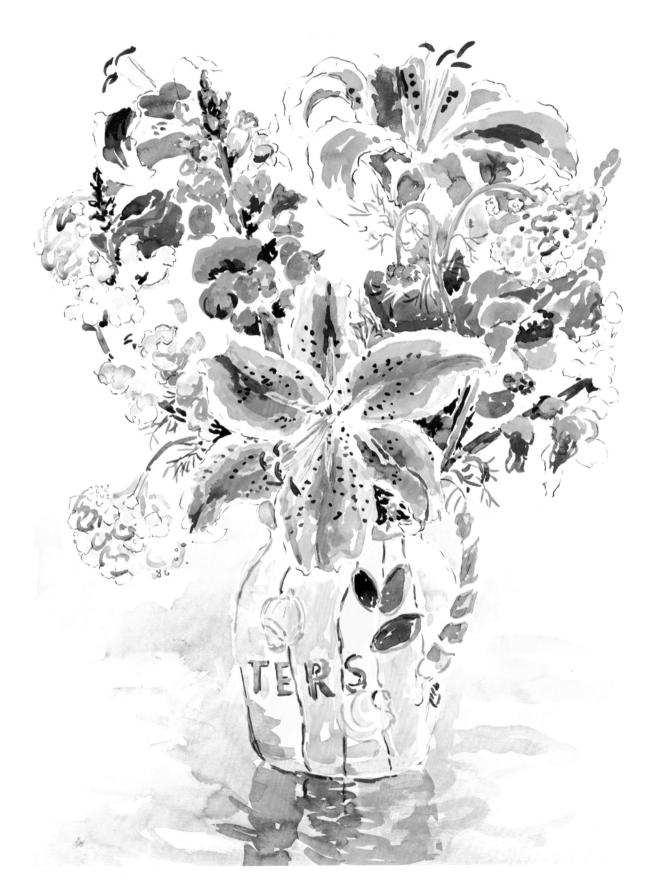

Pink Pitcherful, 2004; Watercolor on paper; 23 × 17½; Collection of Mr. and Mrs. Richard F. Brueckner

A Mentor, Anytime

Imagine if I'd had a mentor, a slightly older man,
who was wise and understood both worlds . . .
the inner, the outer, how to weave them
together, an ever expanding tapestry.

Who would speak to me of mystical things,
take me by the hand, his arm around my shoulder.
With his eyes, his voice, his touch, lead me deep
into being. Keep me from choosing a world too small.

I would be the age I was
when a conversation dropped me
into depths of myself not yet encountered
with a boy I met on a mountaintop . . .

and never saw again.

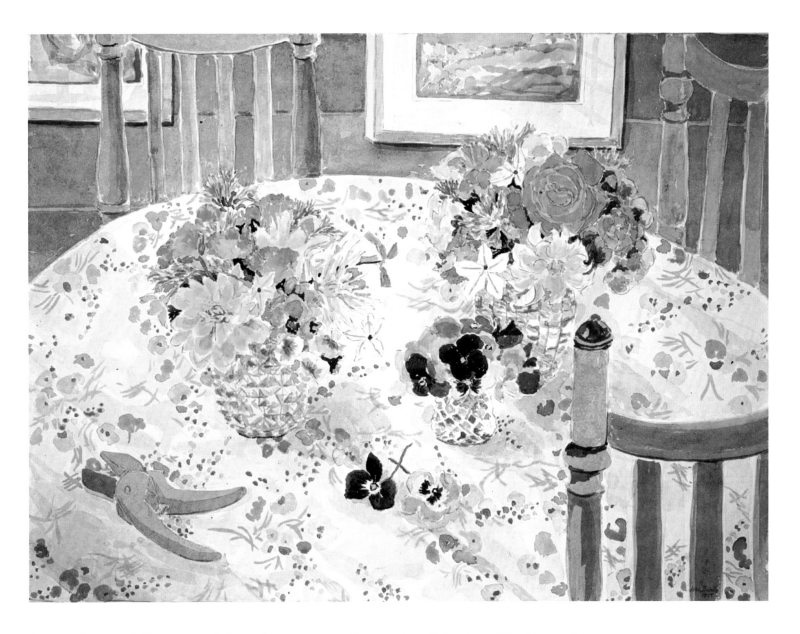

Summer Flowers and Clippers, 1985; Watercolor on paper; 22¼ × 30 inches; Collection of The Newark Museum

Plugging In

In Silence, in sparkling water,
thunderstorms and gentle rain,
in breezes, in a sunset …
Become one with the One.

Take a giant step, begin.
Doors will open, the phone will ring.
The pieces fall in grand design,
 a jigsaw puzzle, designed for you.

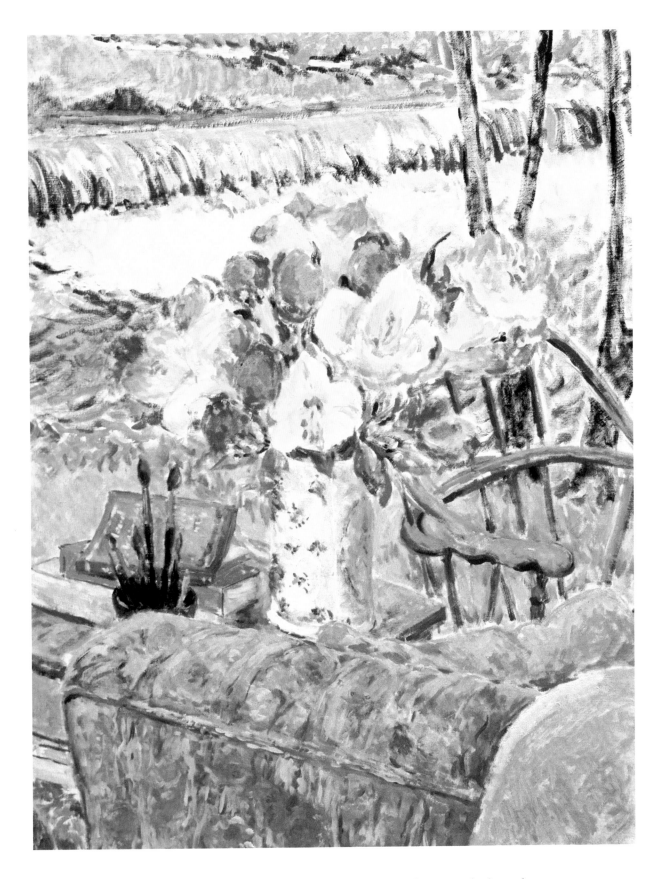

Waterfall from Studio, 1992; Oil on canvas; 40 × 34 inches; Collection of Susan and John Jackson

The Messenger

Connecting the dots,
one to the other.
Then, getting out of the way.
Enough, though she used not to think so.

Used to want to go along for the ride.
Instead, she'd be left alone on the shore,
watching their ship sail away
to imagined places she might never know.

Later, she got it. Understood
her own piece of the puzzle.
Her role. No more, no less.
No past, no future. Now.

She had thought it was too easy,
thought she hadn't worked hard enough.
Now, there's freedom in turning it over,
just listening for the "incoming call."

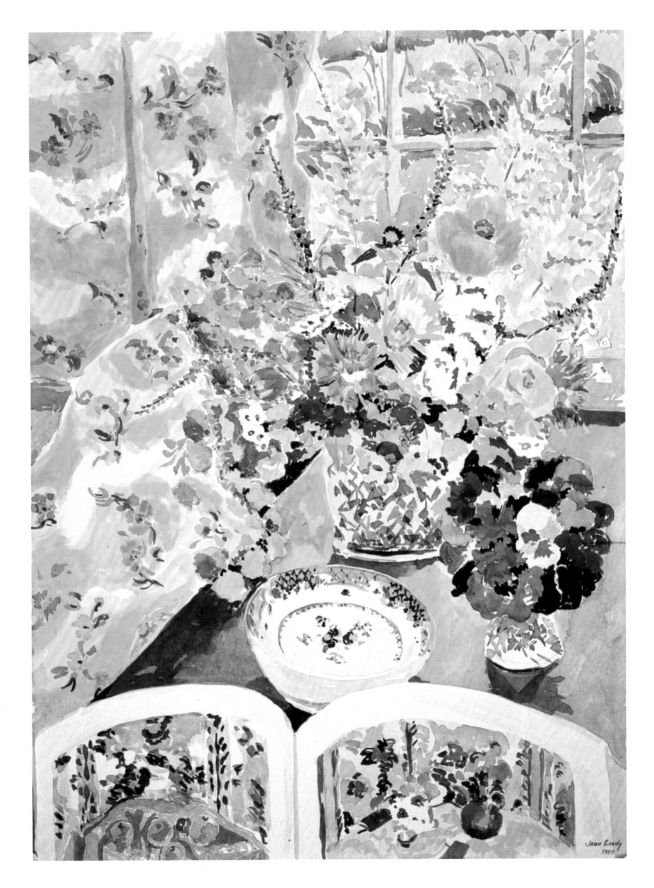

Open Matisse, 1987; Watercolor on paper; 29 × 22 inches; Collection of Mr. and Mrs. John G. Ordway

Finger Painting

Audrey and I walk down to the studio together with the new set of finger paints she got for her second birthday.

I put my much-too-big pink shirt-smock, already covered with dried smearings of paint, on her, folding the sleeves way up over her tiny elbows, lift her up on my black swivel chair and pull her close to the wooden drafting table. I open the cold-cream-sized jars of orange, red, yellow, blue, green, and purple goo, and lay out sheets of shiny paper to paint on.

I try to translate into two-year-old understanding how to take just a little bit of paint out of each jar, to make a picture from that. Again and again, she plunges her whole little hand up to her wrist in the gooey jars, bringing up handfuls of slimy gel, then rubbing or dumping it on the paper, her smock, and the floor.

Inspired by her obvious fun, I begin to lift globs of the paint with my index finger and soon wallow in my own messes, creating a finger painting of Audrey finger painting.

When she says she wants to get down, I begin wiping up the leftover paint, telling her not to move. There is now more paint on her, on the table, the papers, than there is left in the jars. She puts her bright red hands up behind her head and now there is paint in her hair as well. She looks like a little punk rock star when we are finished.

Just then, I hear the clump-clump of Annie's feet coming up the studio steps. She roars with laughter when she sees her small abstract artist.

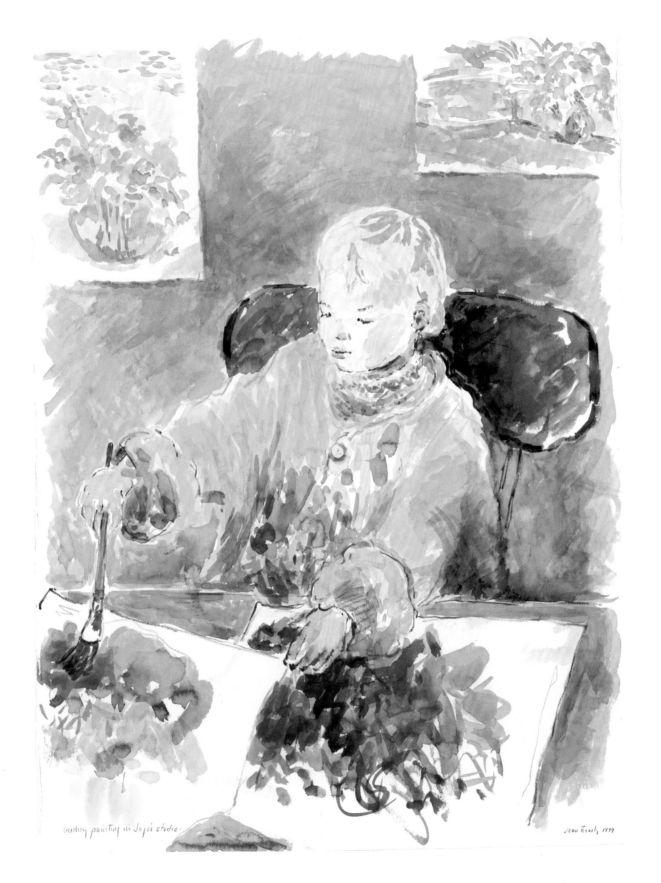

Audrey in Pink Smock, 1999; Watercolor on paper; 30 × 22 inches; Collection of Anne and Jim Brady

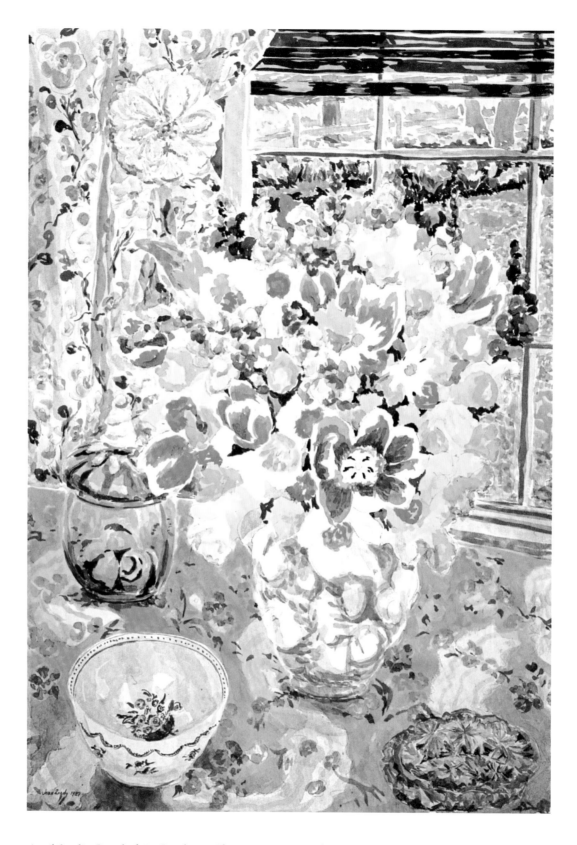

April Studio, Rugalach in Cranberry Glass, 1987; Watercolor on paper; 40 × 26¼ inches;
Collection of Cathy and Bill Ingram

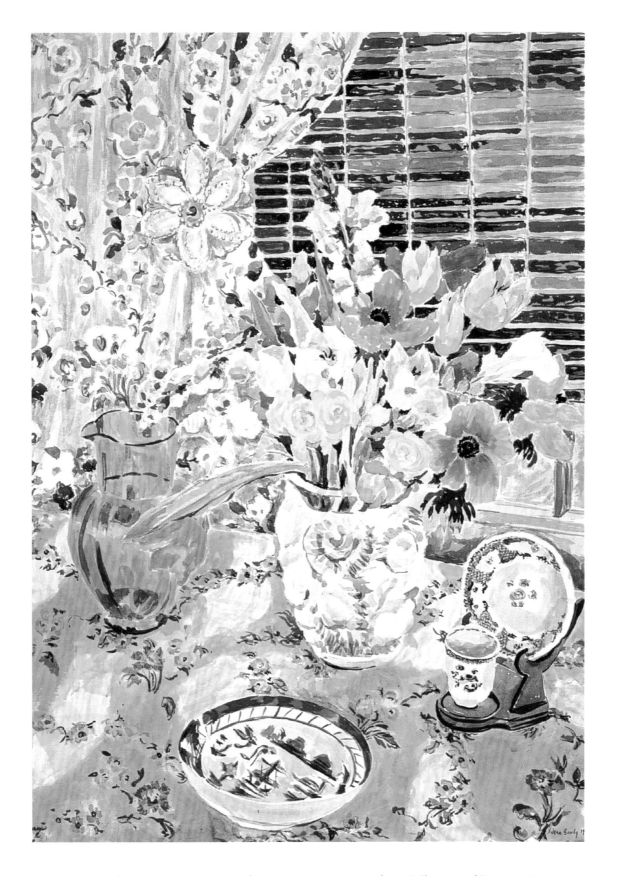

Two Patterns, Lalique Vase, 1987; Watercolor on paper; 40 × 29 inches; Collection of Patricia Hagen

Aughty Aught

It's "aughty aught,"
the slate wiped clean,
tethers unloosed, begin again.

The rules have changed,
the edges gone....
Pure joy with Someone Else to steer.

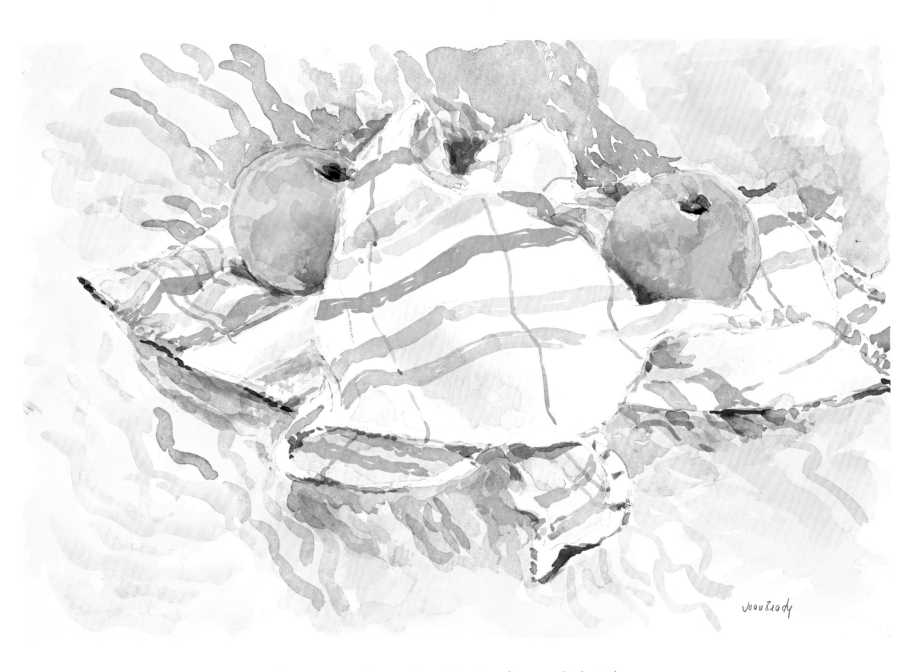

Two Green Apples on Dish Cloth, 2005; Watercolor on paper; 11½ × 17 inches; Collection of Susan and John Jackson

IN GARDENS

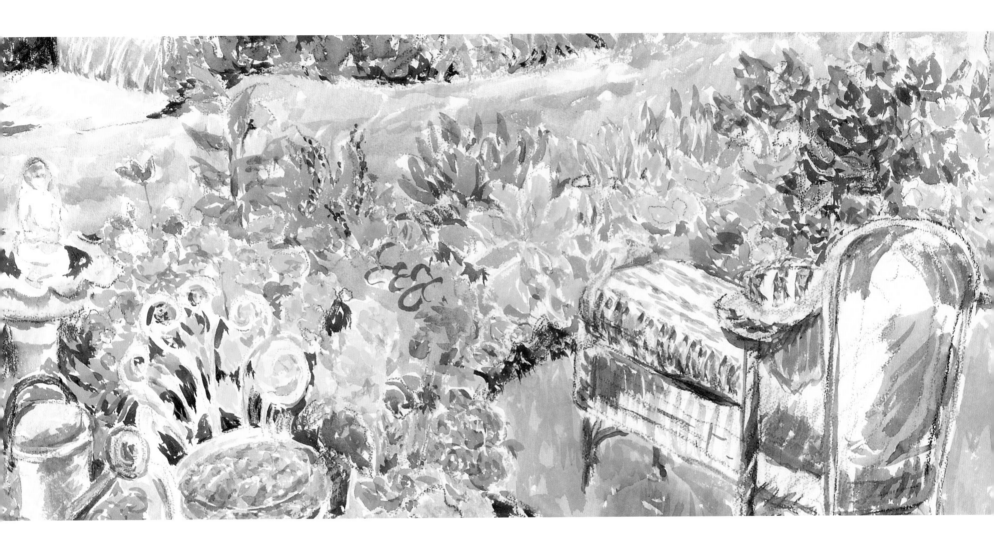

In gardens, in collections of flowers, all interwined.

I find the still point, the fertile ground, in which I lose myself . . .

and find myself again.

JOAN BRADY

Gardening like Painting

Aaaahhhh, rain! Everything looks pretend green, it's so luminous. The swollen flowers seem to be applauding quietly. Each week, my gardens look different as the early bloomers die back, lose their heads, and the newer bigger perennials push up and out. I added some annuals … nicoteana, cosmos, petunias, impatiens in between, so that they will fill in the gaps later on. Everything holding hands, absent-mindedly.

Really, it's just like painting. And also like leading an orchestra … up, up, up … a little louder here … bring in the horns … let the drums die down … a wave of white, a few accents of pink.

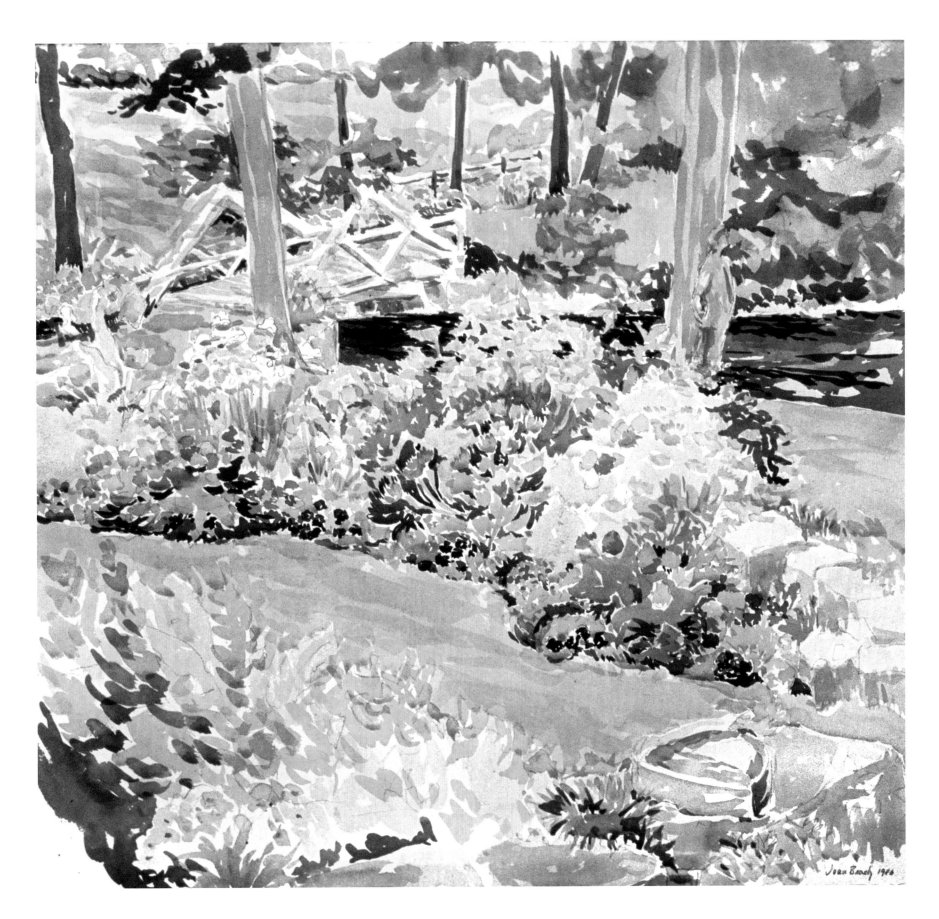

View of Garden from Kitchen, 1986; Watercolor on paper; 22 × 22 inches; Collection of Cathy and Bill Ingram

May Meditation

A chill in the air, my bare ankles cold.
The warmth of the early morning sun
sweet on the left side of my face.
The spring garden, a hard wooden bench.

Alone, but not at all alone.
Pale scented beauty surrounds me.
The wren, returned to the old apple tree,
sings. My heart breaks with his joy.

Further away, a mourning dove's song
reminds me that my own sadness
has used up too much of my time.
Abandon it to ecstasy, surrender to Love.

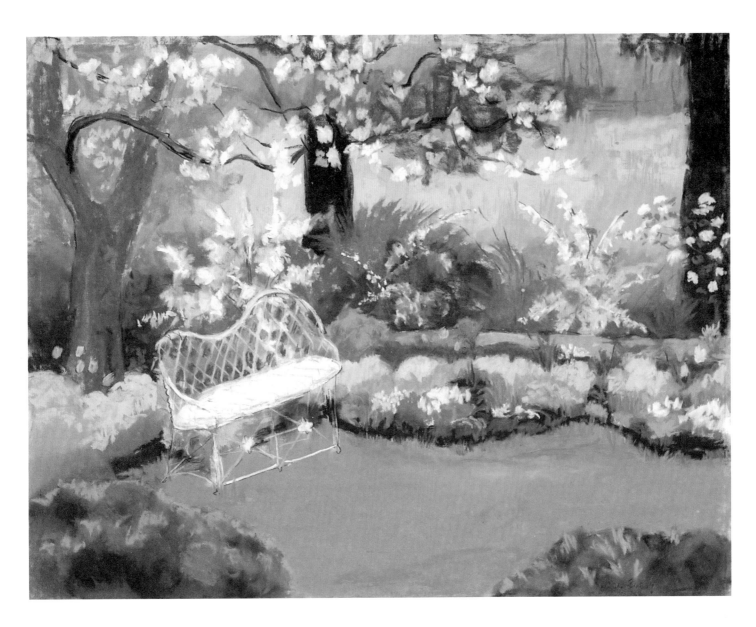

Pastel of Garden, 1980; Pastel on paper; 11 × 14 inches; Collection of the artist

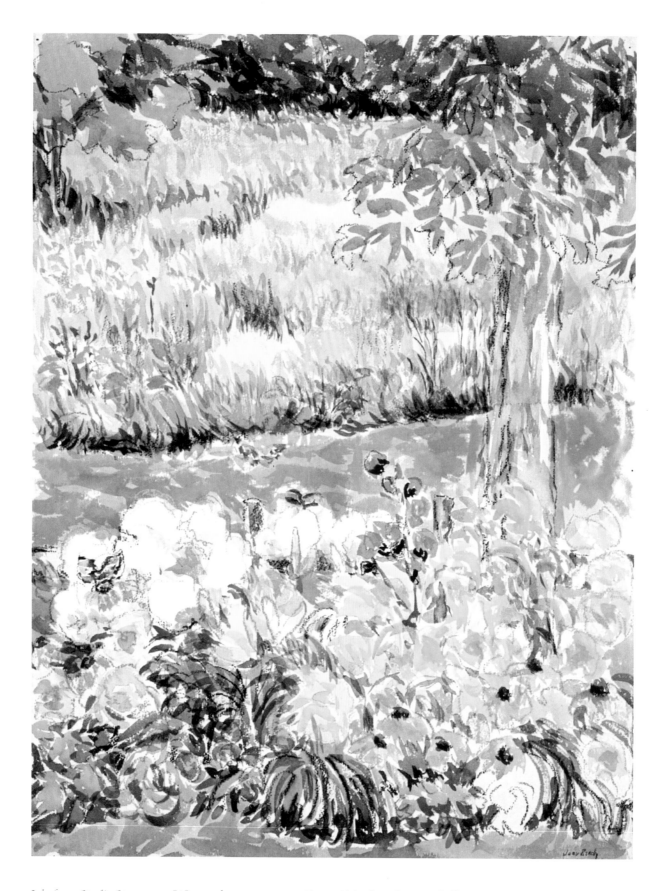

July from Studio Step, 1994; Watercolor on paper; 29½ × 41½ inches; Private Collection

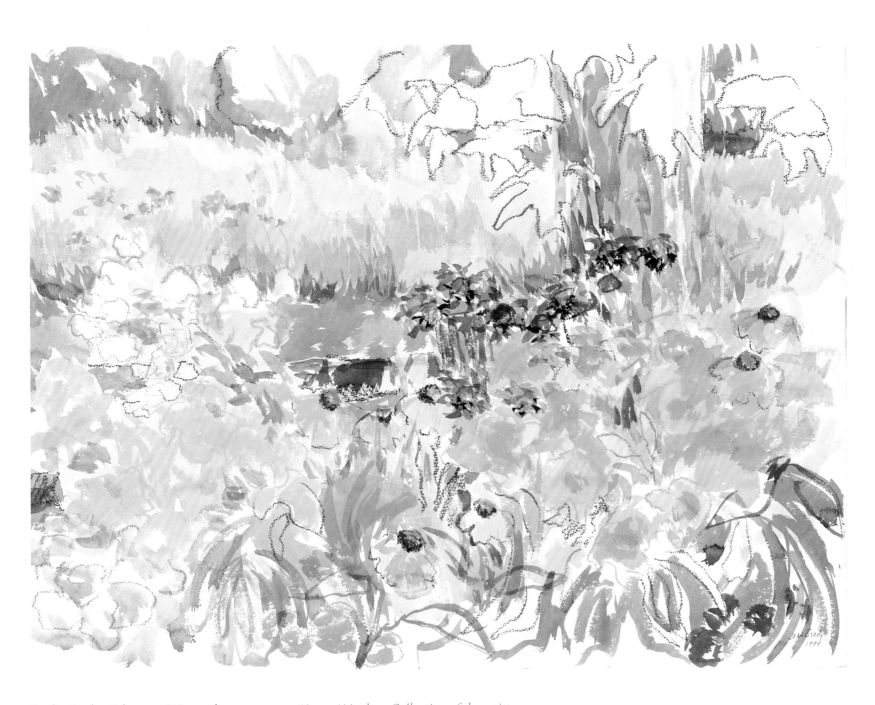

Studio Garden, July, 1994; Watercolor on paper; 29½ × 41½ inches; Collection of the artist

Sometimes More is Better

Several vases filled with peonies, my favorites.
Carrying one around like a new baby, I wonder
whether to paint the arrangement inside
or to paint the peonies still in the garden.

Undecided, I place the vase of flowers and a pair
of green clippers on a round glass table,
then push the entire tableful
up against, kind of into, the garden.

Sometimes, more is better!

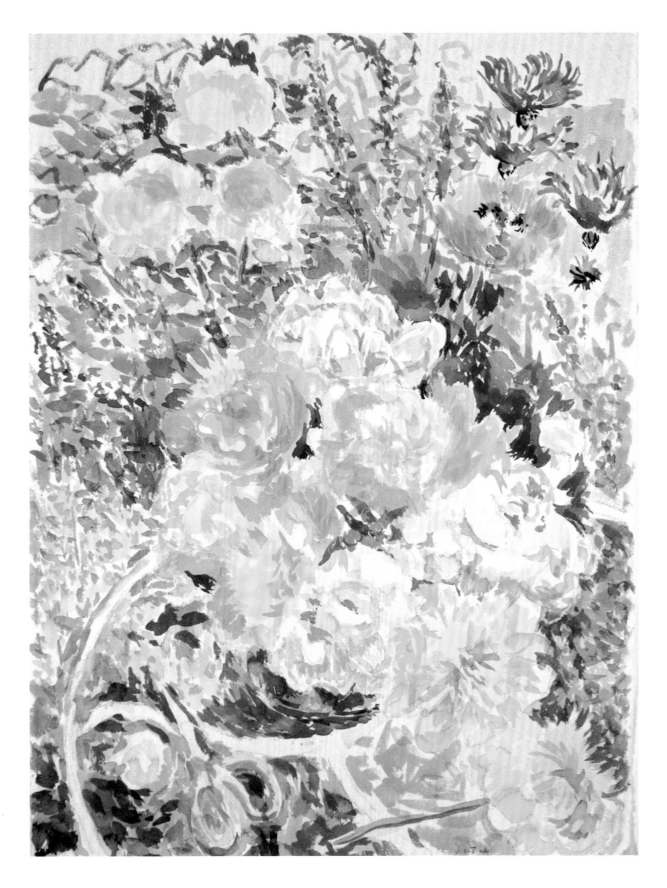

Peonies on Glass Table with Clippers, 1999; Watercolor on paper; 30 × 22 inches; Collection of the artist

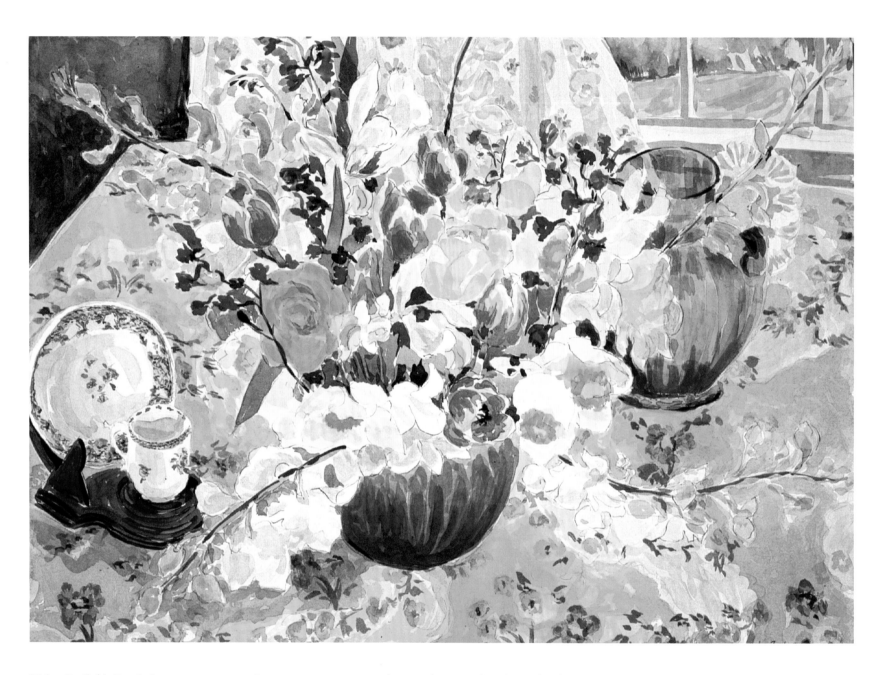

Tulips Daffodils Dendrobian, 1987; Watercolor on paper; 22 × 30 inches; Collection of Cathy and Bill Ingram

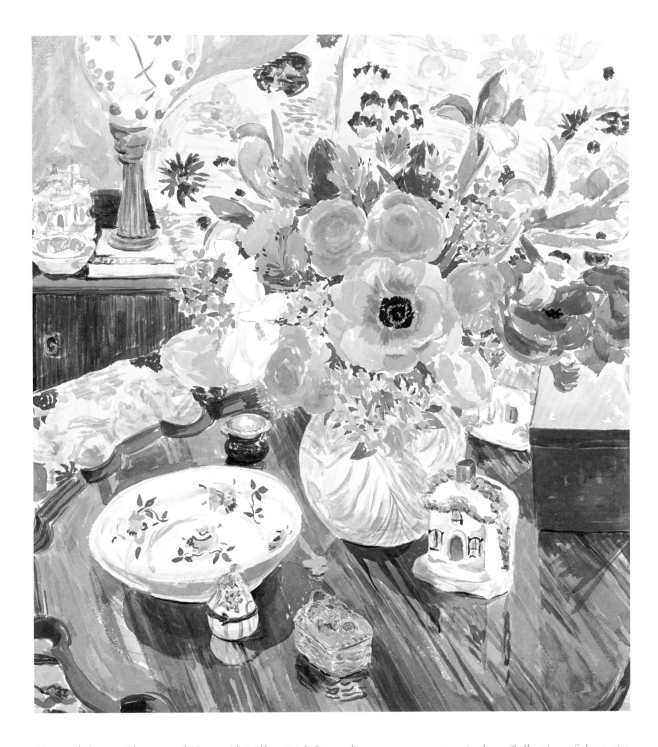

House of Flowers, Flowers and Houses (detail), 1986; Watercolor on paper; 40 × 29 inches; Collection of the artist

Calling the Beloved

Walking by the river, the breeze ruffles my hair.
I remember the dancing, sense Him nearby.
Ah, He wants to lie down in the grass.

How many times, how many spring times
have I longed to lie in the grass, do nothing
with someone who felt the same urge.

Now, Someone is pulling me down … down …
and I follow, falling onto my back, laughing,
down on the grass under the ash tree.

This is what I hear Him say …

"You need to dance with me! Let me hold you, show you,
lead you. You've been looking in all the wrong places,
everywhere but where I've been waiting.

I am everywhere … in the wren's song, in the breezes,
in sparkling water, in the flowering of your garden,
the thrill of conversation, your grandchildren's laughter.

If you'd only take more time to watch, to listen.
Stay with me. Let's dance again … and never stop.
Life is a banquet right under your nose.

You are never alone. Wherever you are, I AM."

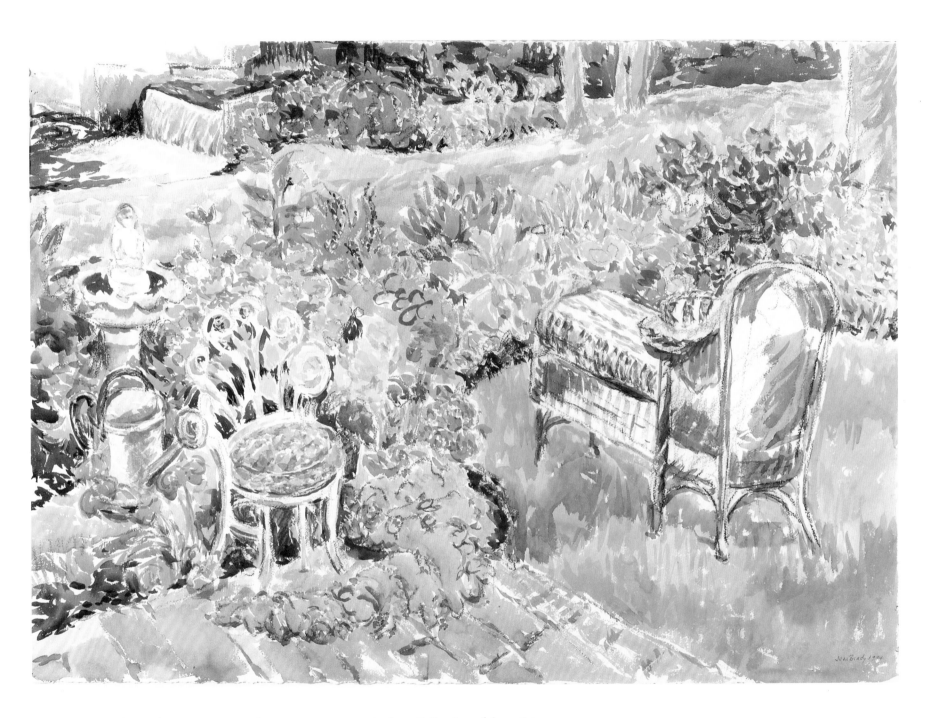

Chaise Longue, July Garden, 1994; Watercolor on paper; 30 × 40 inches; Collection of the artist

Beyond Flowers

Beyond flowers,
beyond the garden gate,
into secret places, unexplored.

The light of this new time
illuminates some. In others,
paleness in yesterday's faith.

Some need a touch of courage still.
Or is it just a shift of vision
from not daring to claim it all?

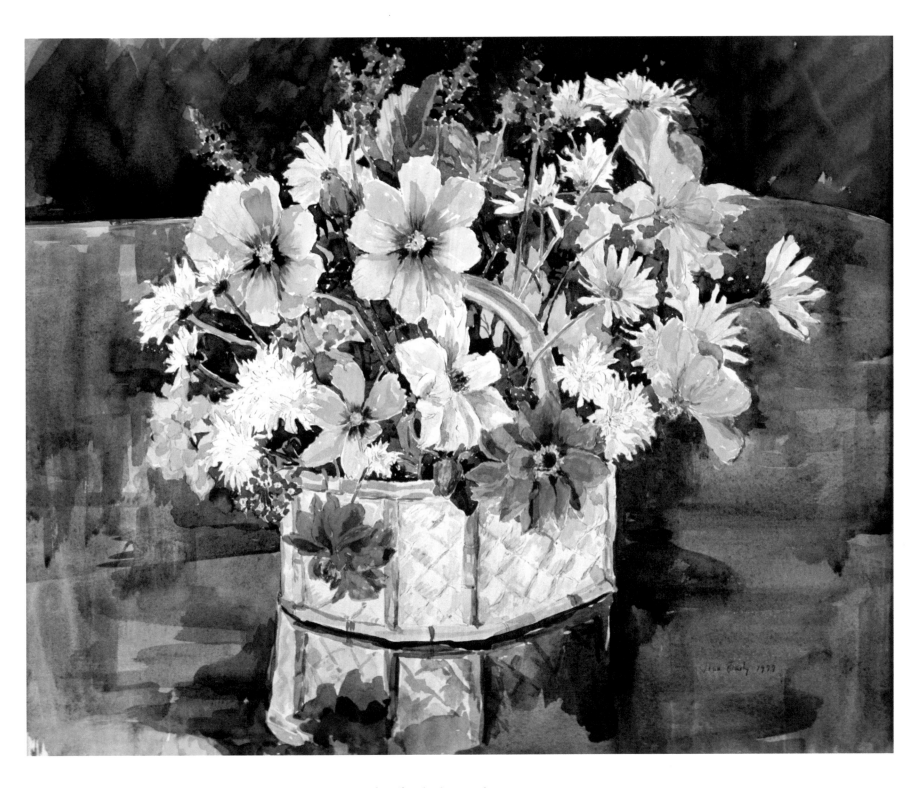

Cosmos, 1977; Watercolor on paper; 18 × 24 inches; Collection of Buff and Johnnie Chace

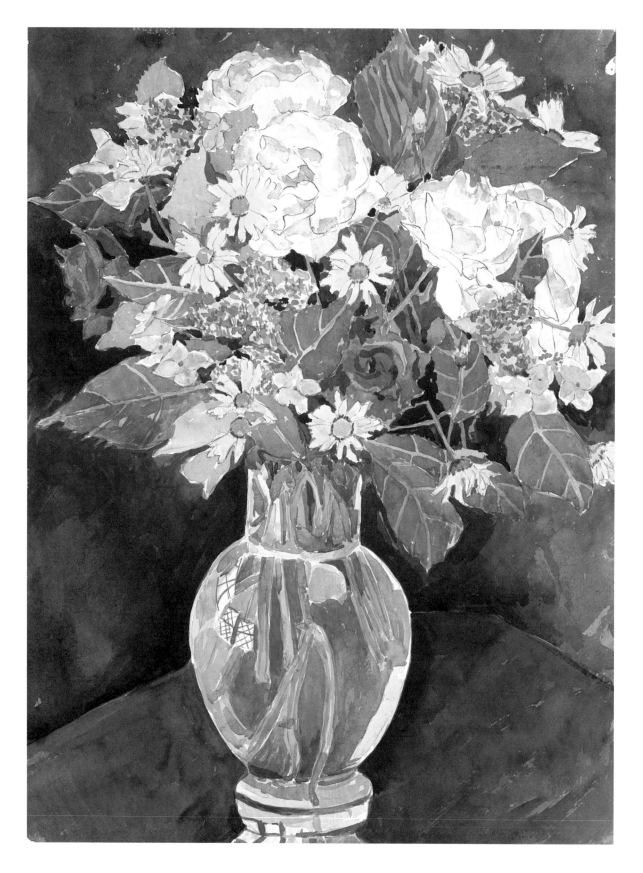

Mill Neck Bouquet, 1977; Watercolor on paper; 24 × 18 inches; Collection of the artist

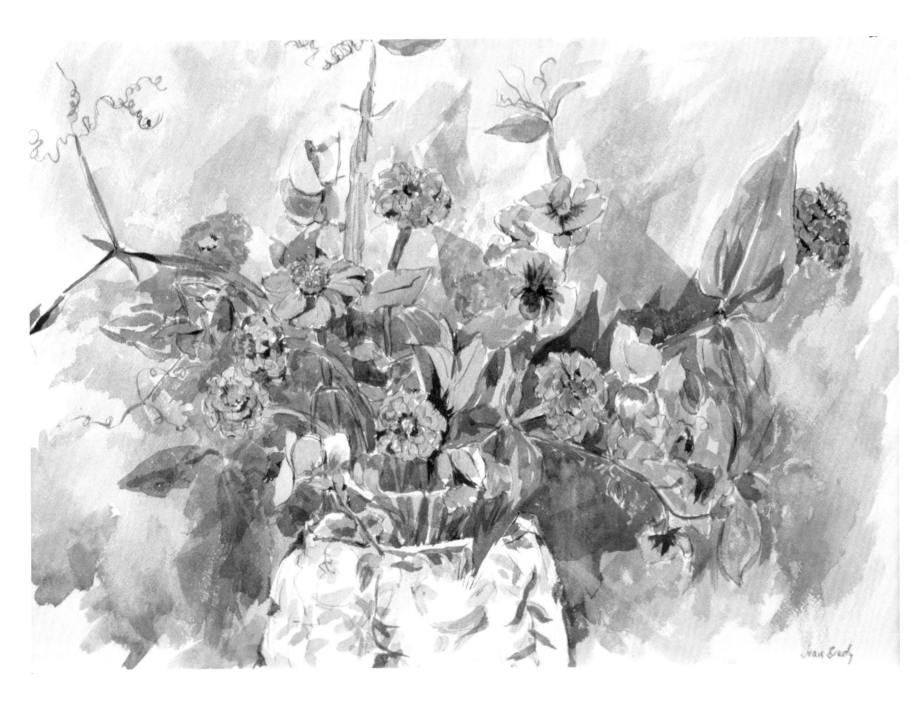

Zinnias, 1977; Watercolor on paper; 18 × 24 inches; Collection of family of Elizabeth Boies Schley

Night Light

I am back in the garden, adjusting my eyes to the dark to see what I can see, my face close to the plants to see them, smell them, touch them. Down the far stone steps, carefully maneuvering the uneven thyme-covered stones in the night. Across the lawn … to the bridge … to the flower beds there.

The flowers look larger than life, light up in the blackness and quiet of the night. I move carefully over the bridge and towards the waterfall, next to the dam, to the Bonica and Miediland roses. Gradually, as if in slow motion and, yet, suddenly, the whole bed of roses is infused with light. The flowers are lit up and enormous. Behind them against the dark trees, as high as I can see, the fireflies over the river turn into towering New York City skyscrapers. Light against dark everywhere I turn. Now, the light overwhelms the dark, overwhelms me.

I am filled with a feeling of pounding energy. I touch, I kiss a flower. It tingles on my lip. My heart is beating, my head feels too light. There is ringing in my ears that echoes and magnifies the sound of the waterfall. Electricity. Radiant light. Racing heart. Supercharged energy between me, the fireflies, the pulsating flowers, the expanded moment. Too powerful to withstand.

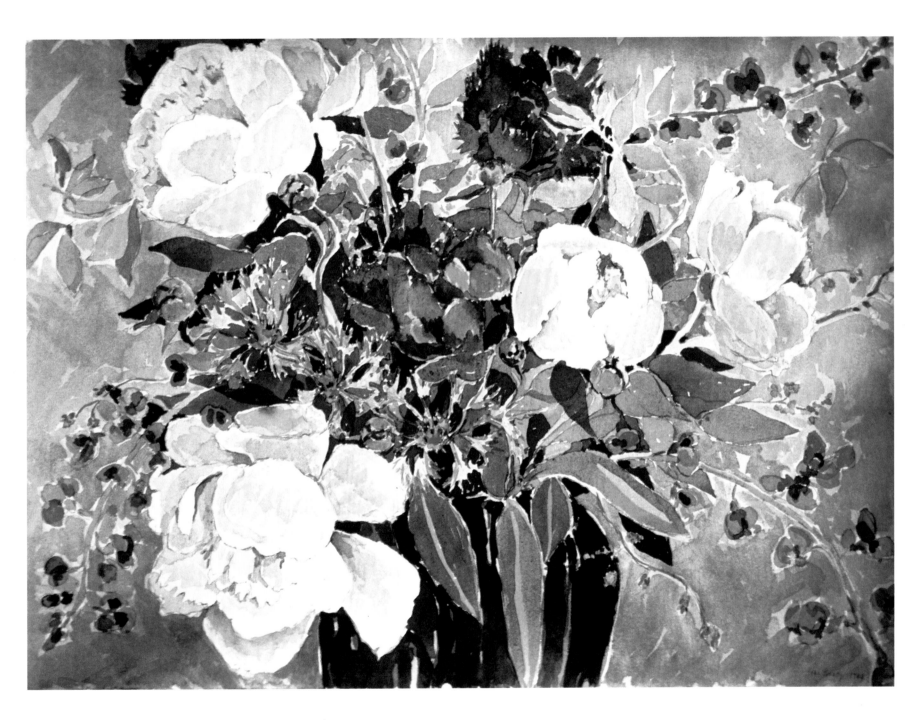

Peonies and Centaurea, 1982; Watercolor on paper; 22 × 28 inches; Private collection

Do You Remember?

Melt inside. Let hot lava
stream, burn away
debris, all that the world
told you was the truth.

It isn't now and never was.
"In Wildness . . ." we remember.
But you have forgotten.
Nothing left but ashes.

All there, deep, deep inside,
banished by the "niceness"
they taught you to wear.
Who is the girl you sent away?

Search for her, free her,
make her part of you again.
Not separate, projected
on to some unworthy fool.

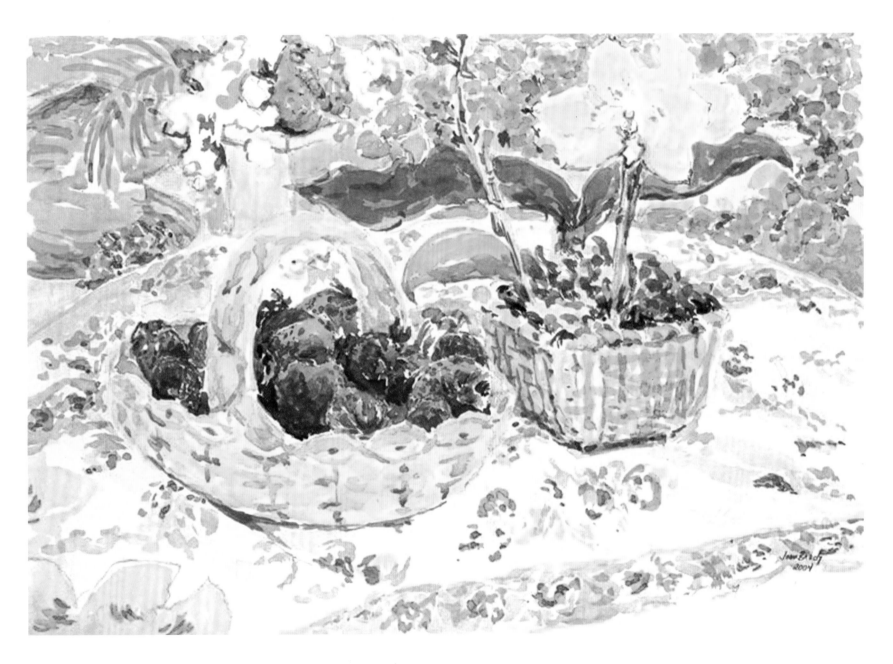

Strawberries for Henry and Liberty, 2004; Watercolor on paper; 19 × 14 inches; Collection of Henry and Liberty Yates

Labor Day

Something growing inside of me, coming to life.
Something between me and I, only tasted
in the past, while making love.
I don't need a "him" anymore.

A feeling in waves of sadness and gladness,
both sexual and holy, all merged together.
Thunder rumbling in the distance.
Wetness, gray and windy.

Warm and rosy, coral and peach
inside me … low, hot embers.
Perhaps someday again I'll burst into flames
and burn up the unnecessary things in my life.

I love this feeling. Preorgasmic.
Physical, Godly together.
My heart feels larger, as though it might heal
anything amiss in my body, my mind, the world.

If I were to speak now, the words
would be wise … from a place so ancient.
Silence for now.
I am love. That is all.

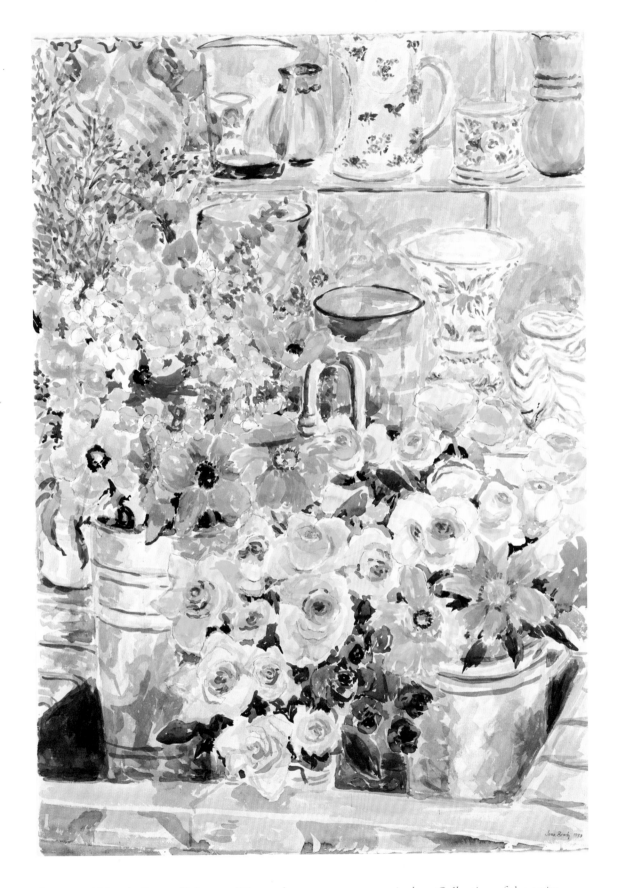

Flowers and Vases in Pantry Sink, 1993; Watercolor on paper; 41 × 30 inches; Collection of the artist

Hummingbird

Excited to begin a new watercolor, I set up my French easel just outside the kitchen.

I stand and stare at the early morning light illuminating the garden, in wonder at the beauty of it all. Suddenly, a hummingbird flies right in front of my face like a tiny helicopter. His throat is cranberry red. Hovering, vibrating, he seems to look directly into my eyes for a moment extended, expanded.

And then, he is gone in a whir.

"God's in His Heaven: All's well with the world!"

What does the hummingbird remember
that we have lost track of now?
There is no separation within
the implicate order of things.

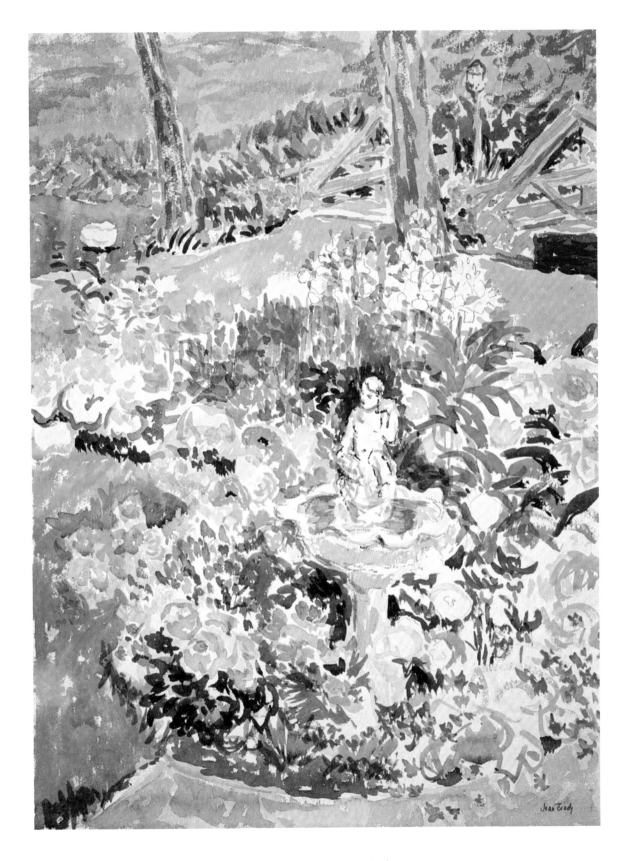

Birdbath, Garden, Bridge, 1999; Watercolor on paper; 30 × 22½ inches;
Collection of Mr. and Mrs. Philip D. Allen

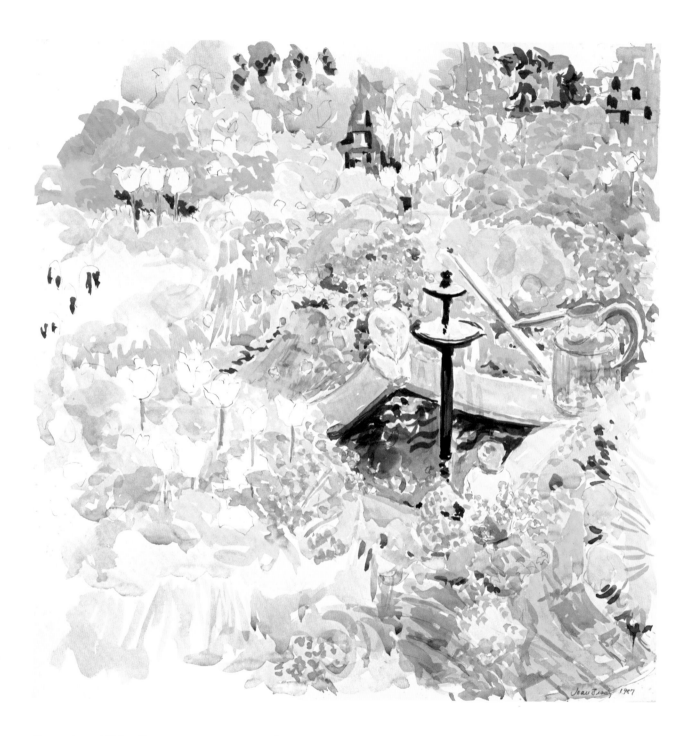

Fountain and Phlox Divaricata, 1987; Watercolor on paper; 22 × 22 inches; Collection of the artist

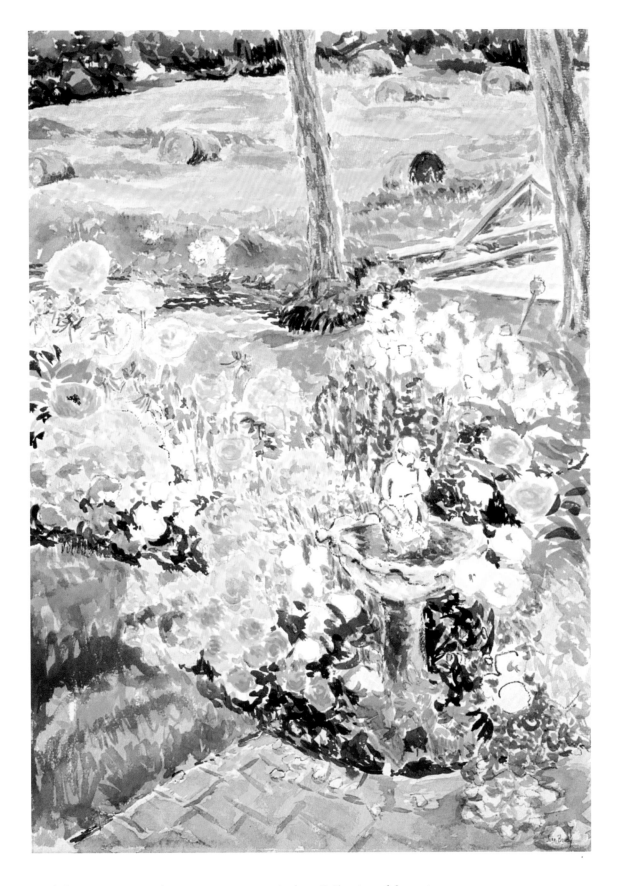

Haybales, 1999; Watercolor on paper; 40 × 30 inches; Collection of the artist

Her Secret Garden

Ah, she has not seen until now
that what she thought she had been denied
is, simply, all of who she already is.

She didn't look it, at first, but now that I know her …
now that she has told me her story,
now that I have seen her gardens, her paintings,
have tasted her cooking, have heard her weep,
and watched her laugh as she danced until other tears came …
I know her secret garden with its soft pastels.
But I can also see the red behind them
which she has, too often, ignored.

And underneath, the rich, dark humus,
the ancient, rotted soil
that has made her garden grow.

She understands, after her time in silence,
the importance of looking beyond
the beauty of the wildflower,
the way it looked at first glance,
to what lies beneath. What the flower has grown in.
To everything that has gone before
in her life. The compost of her garden.

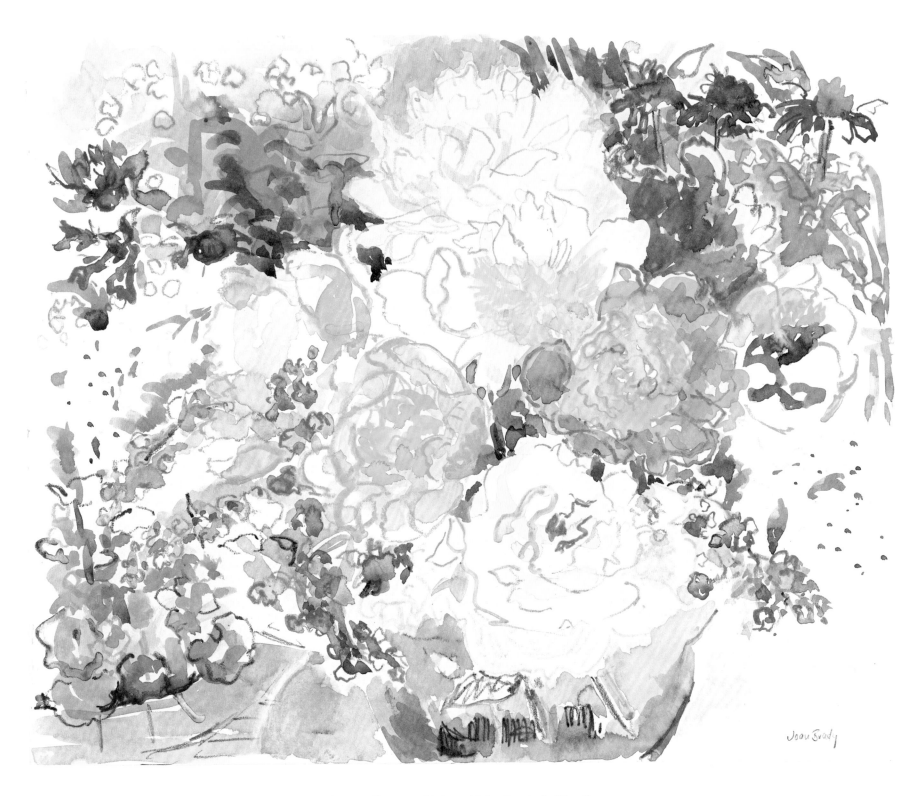

Smoosh of Peonies, 1999; Watercolor on paper; 15 × 18 inches; Collection of Mr. and Mrs. Frank A. Kissell

VOYAGING OUT

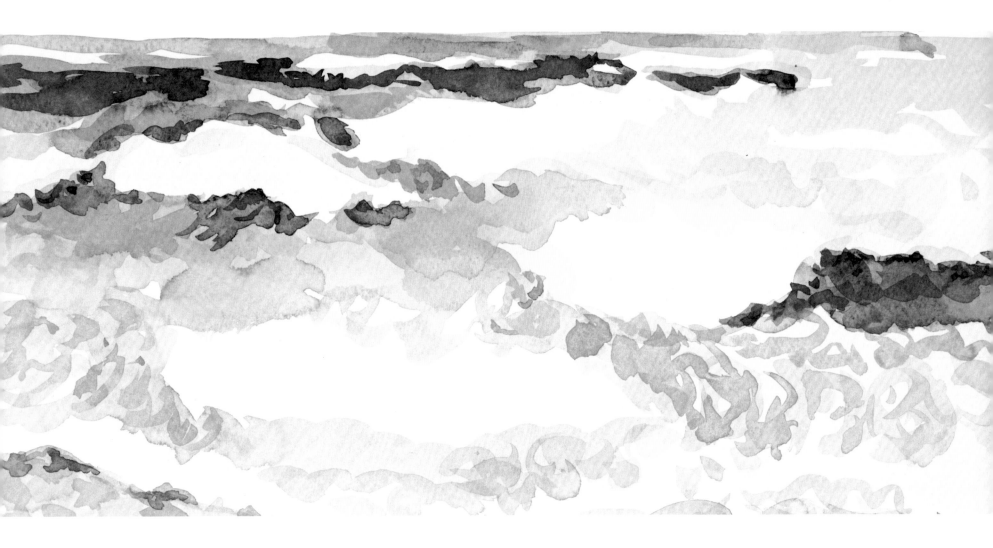

*Maybe all remembering has the same purpose …
to restore what is lost, to make the unruly fragments
of lived experience a coherent whole.*

ELIZABETH CUNNINGHAM, *The Passion of Mary Magdalen*

Painting Waves

Away from Still Lifes into waves …
formless, uncontrollable.
No beginning, no end.
Somewhere I haven't been before.

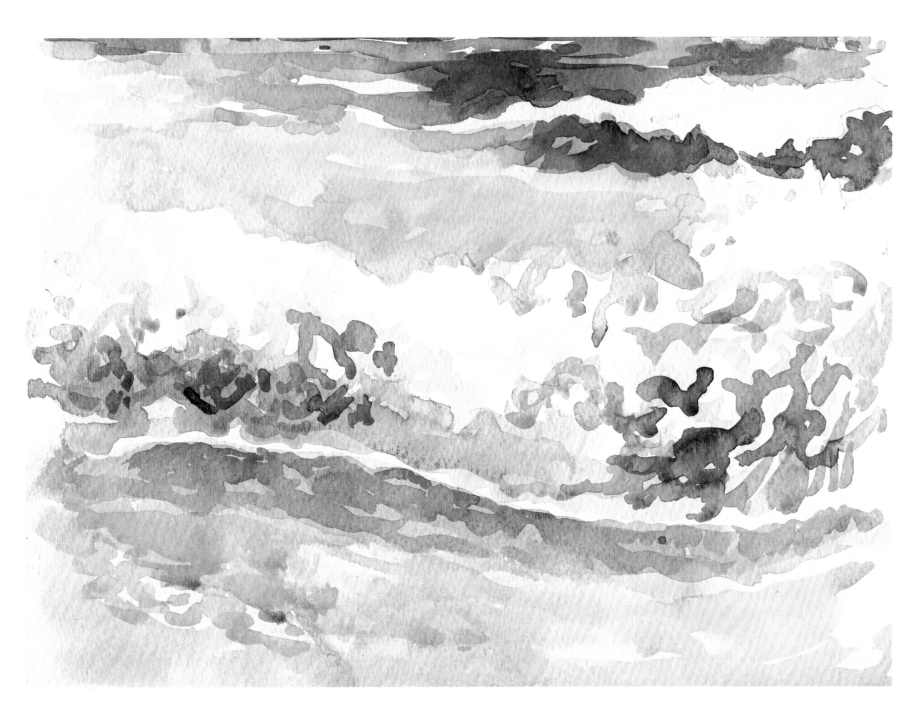

Undertow, 2001; Watercolor on paper; 9 × 12 inches; Collection of the artist

Only in the Twenties Today

Right hand like ice, I write.
Bundled in parka, boots, one mitten,
a wooly hat over my ears.
The rest of my uncovered face

warmed by the winter sun.

On the wooden rocker,
the studio porch, facing south.
Blinded by intense white light
from the river below,

unclouding my eyes.

Cold stillness outside, time for hot soup.
A glowing fire in which to see further.
Long underwear and cashmere,
conducive to deeper diving.

No interruptions now.

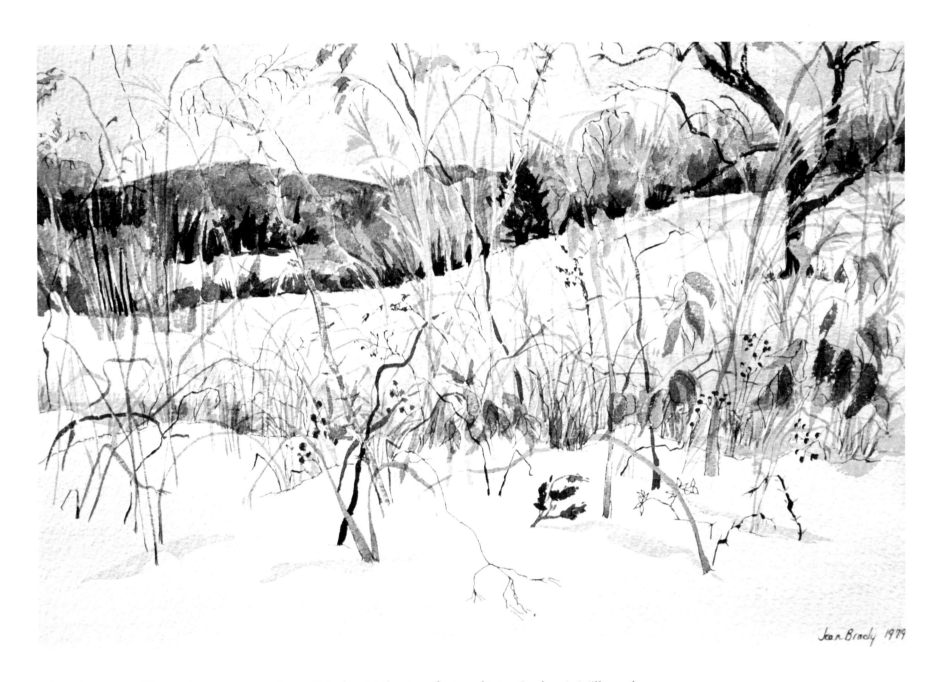

Winter Scene, 1979; Watercolor on paper; 14½ × 20½ inches; Collection of Mr. and Mrs. Gordon A. Millspaugh

Be an Instrument

No better or worse,
nor wiser, nor slower.
Like snowflakes, no two alike.

Begin from a place of trust,
the road to take will unfold,
moment by moment.

You have no idea how big,
how small the task may be.
You'd never begin if you did.

Little miracles all the time
right in front of your eyes,
beyond your wildest dreams.

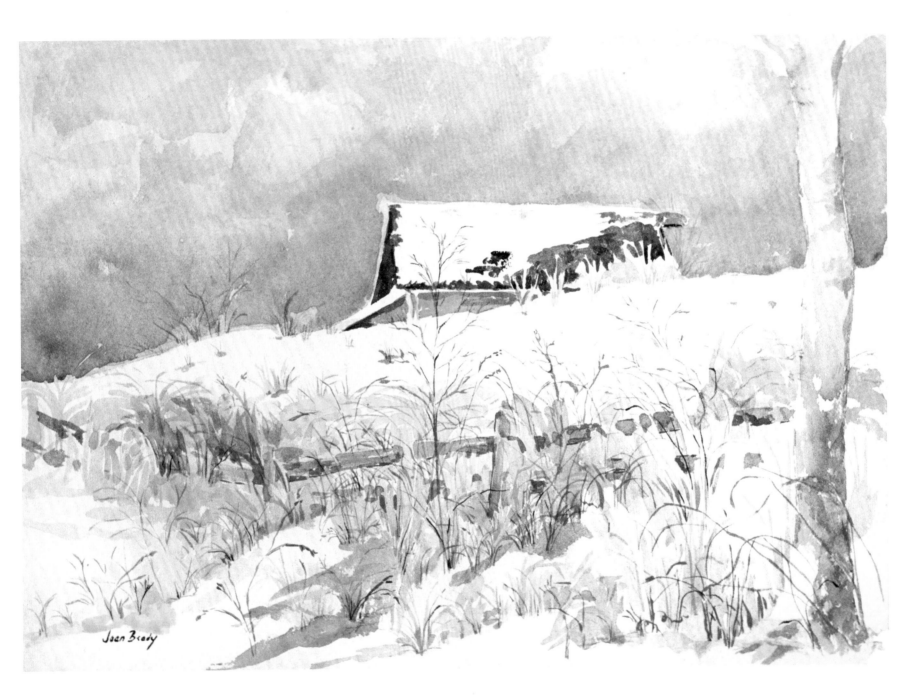

Barn in Snow, 1979; Watercolor on paper; 14½ × 20½ inches; Collection of Kim Brady Cutler

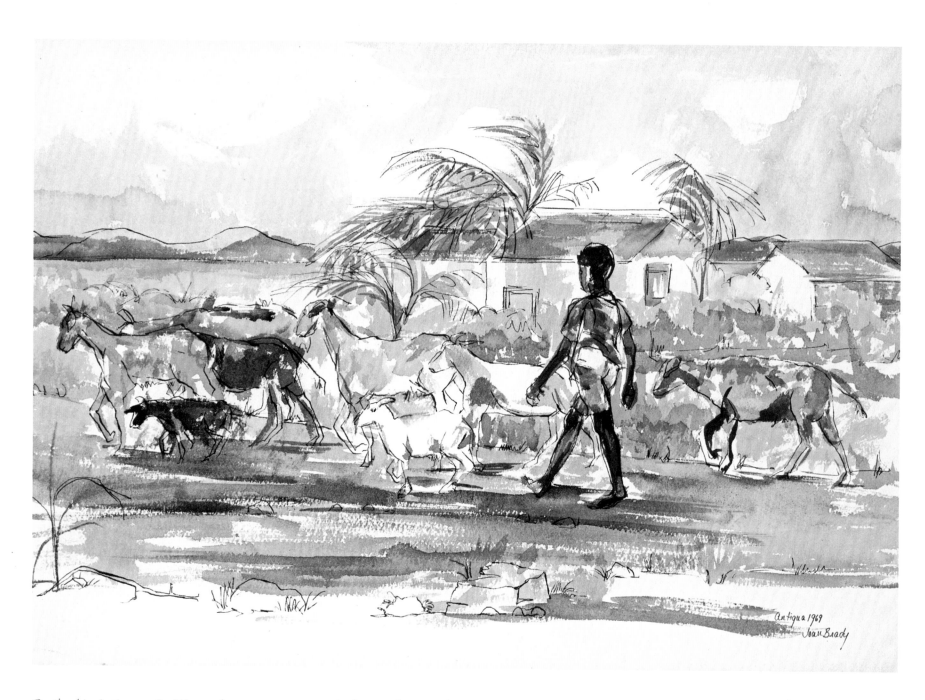

Goatherd in Antigua, 1969; Watercolor on paper; 14 × 20 inches; Collection of the artist

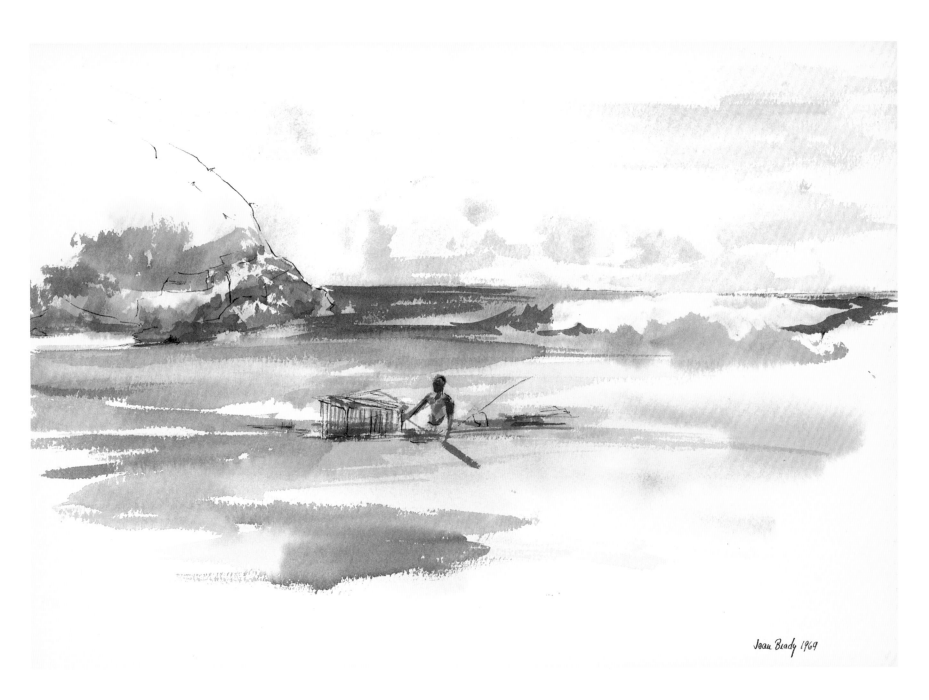

Antigua, 1969; Watercolor and ink on paper; 14 × 20 inches; Collection of the artist

Sunday on the Waterway

I love each boat that passes, the chameleon on the wall,
even my own foot. Today, all things look paint-able.
The boats on the waterway are speeding up now,
hurrying to make the bridge in time.

I, on the other hand, don't want to be reminded of time.

A breeze touches my face, picks up the hair on the left side
of my head, blows over my bare toes … a caress
that touches me throughout, reminds me
of the clumsiness of a human kiss.

What could be more real than this, elusive as it may
seem tomorrow.

Sketch of Boat on the Waterway, 1998; Pen and ink in
sketchbook; 10½ × 8 inches; Artist's sketchbook

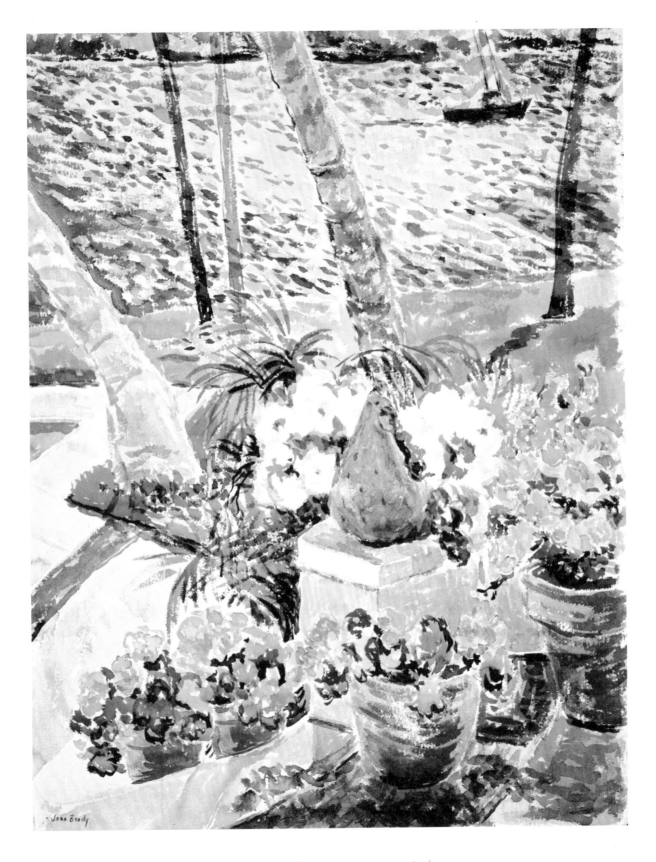

Steps of Flowers, Light on Waterway, 1998; Watercolor on paper; 30 × 23 inches;
Collection of Mrs. Edward H. Gerry

If Only I Could Keep on Dancing

Tiny lights on palm trees
line the winding path.
Jimmy, just ahead,
is asking for our car.

I keep dancing backwards,
staying close to the music.
Remembering younger nights
through all the champagne.

Looking up at stars, reinventing
my youth, wasted on dreams.
In love with the world
until the music stops.

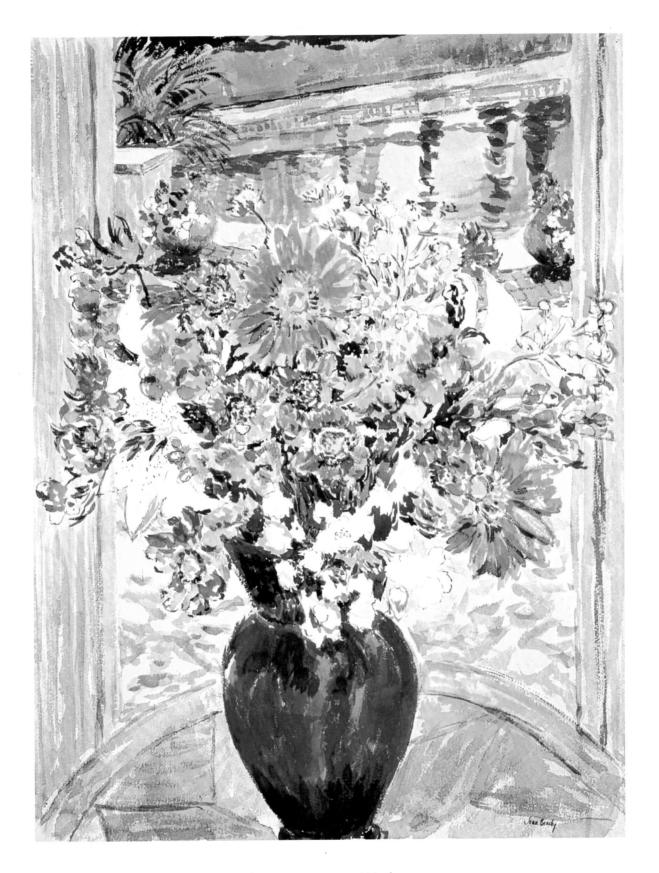

Swimming Pool, Blue Vase, 1997; Watercolor on paper; 30 × 22½ inches;
Collection of Mr. and Mrs. Stuart L. Scott

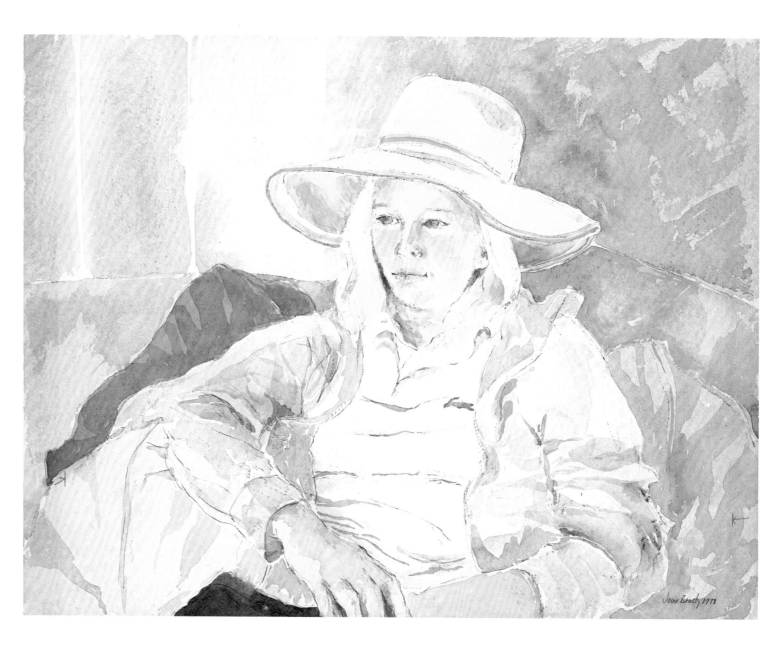

Kerry in Straw Hat, 1978; Watercolor on paper; 17 × 20 inches; Collection of the artist

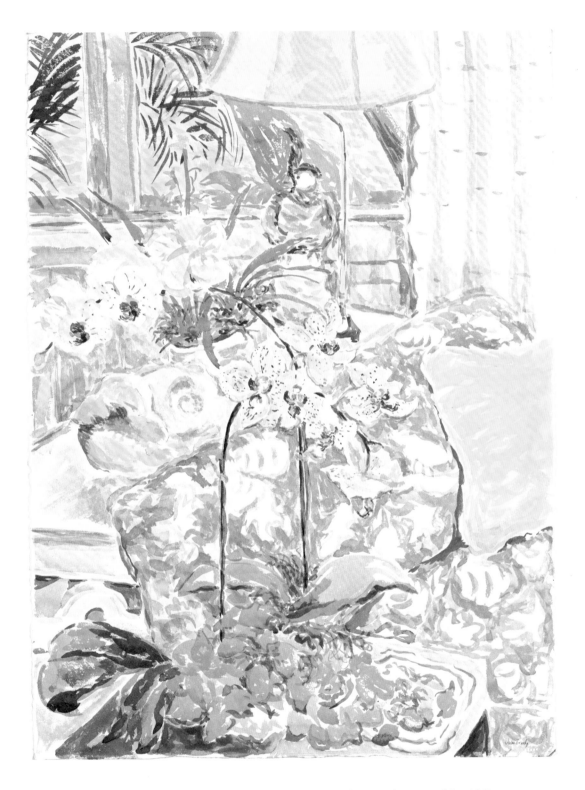

Orchids and Patterns, 1999; Watercolor on paper; 40 × 30 inches; Collection of David Dewey

On the Porch in Florida

A boat goes by to nowhere …
to somewhere heading north,
pulling me away to magical places,
returning me to the now of my porch.

Staring into white light,
diamonds and ground-up glass,
transported deep inside to ecstasy
that lasts until the next interruption.

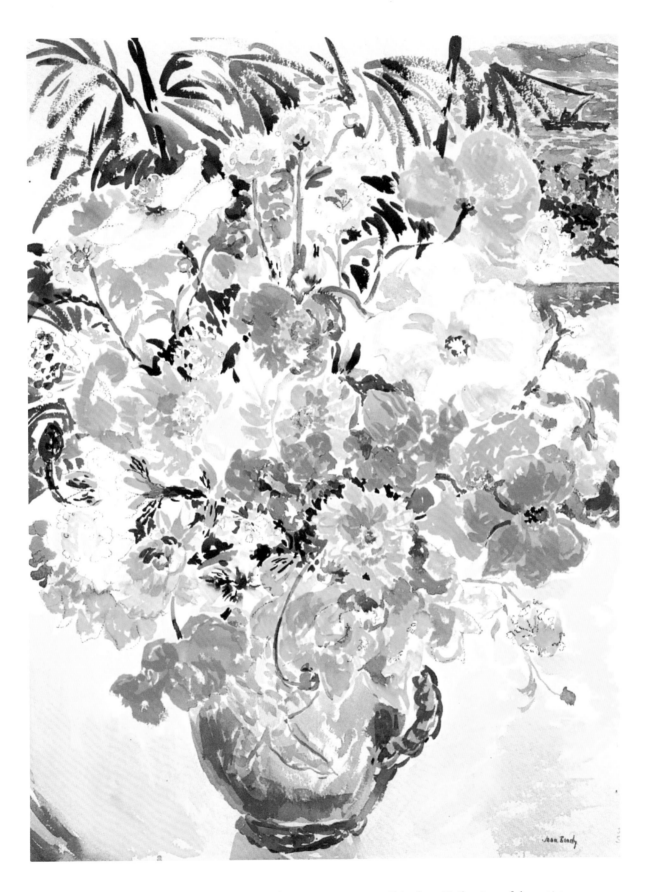

Mostly Poppies in a Starfish Vase, 1999; Watercolor on paper; 30 × 22⅝ inches; Collection of the artist

Font de Gaume

I follow the Frenchwoman, the guide,
through the entrance of the prehistoric cave,
into sudden blackness, thick, ancient air.

Blinking, squinting, I adjust my eyes
to see whatever the pinpoint of light
from her flashlight on the wall will reveal.

Nothing at first. A faint outline, a shape appears.
A bison, markings of ochre, a speck of blue,
A running horse. The cave comes alive.

My heart, my head are pounding.
Ringing in my ears makes me dizzy.
Time explodes, disappears.

Everything happens now.
The artist of so long ago and I …
one hand, one mind, one time.

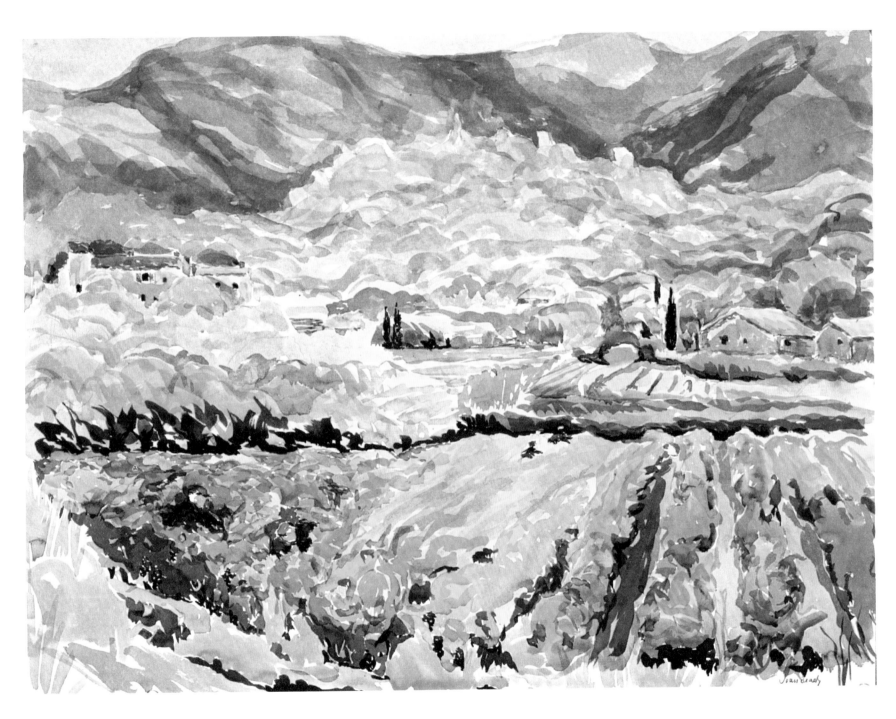

Luberon, 1985; Watercolor on paper; 22 × 30 inches; Collection of Paul and Mary Lambert

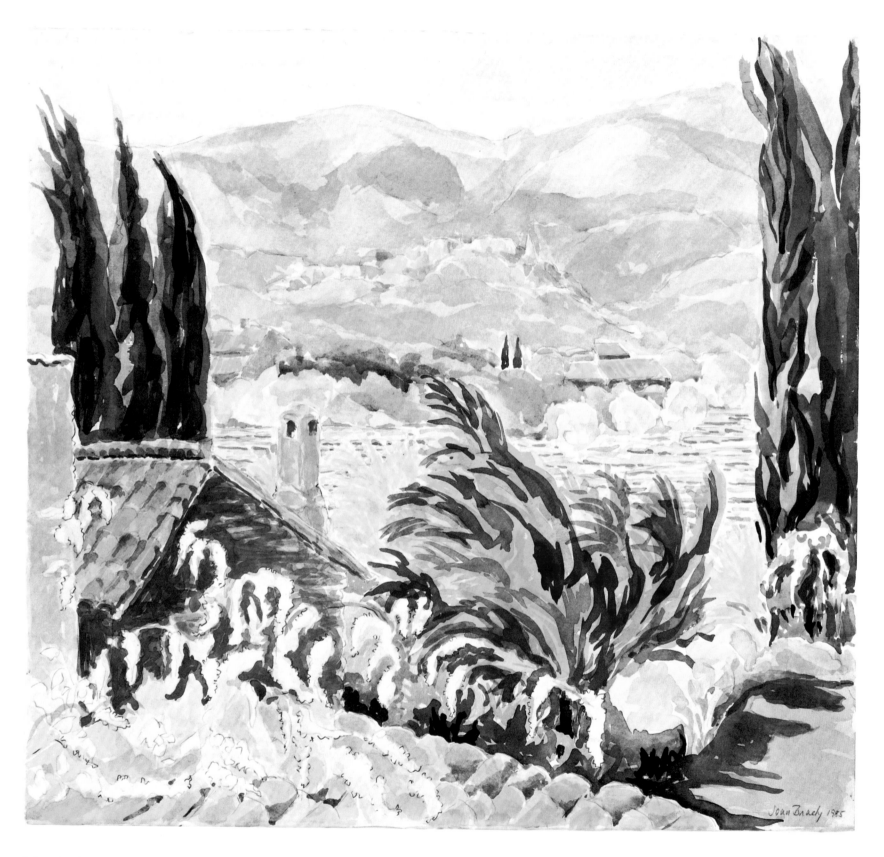

Menerbes from Les Martins, 1985; Watercolor on paper; 24 × 22½ inches; Collection of Mr. and Mrs. Finn M. W. Caspersen

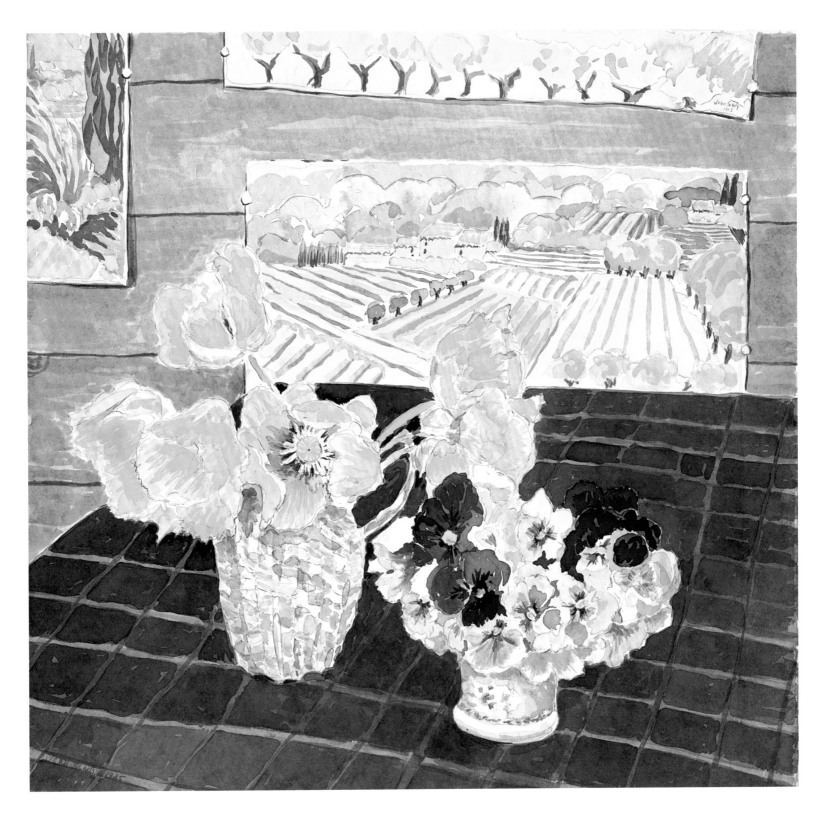

Poppies, Pansies, and Paintings of Provence, 1985; Watercolor on paper; 22¼ × 21½ inches; Collection of the artist

Trying to Fly

I don't know how women artists ever find enough time! There's so much I want to do in painting and so little time. And yet, when the paintings hang on the walls of the gallery every couple of years, I realize that time has been my friend.

Then I look at them, in their finery of gold leaf and glass, wondering how so much got accomplished. Completely forgetting the start-stop times, the interruptions, frustrations, the ups and downs.

I was thinking last night about the difficulty of staying on the "flight pattern." Of being aware of this and even more aware of the slips off it, the seeming backward slides. I remember a dream I had, over and over again, as a young girl.

Trying to fly. I could do it just high enough to stay clear of the lions and tigers leaping and snarling at my feet, below. I could never quite get high enough to be free of them, never really free enough to simply enjoy flying. I never fell, but I never flew without slips, dips down, attacks from grabbing things.

I feel as though I'm trying to fly again this many years later, with all of the same "grabbing things," but knowing where I want to go. Always flapping my wings and straining to be free.

Who was it who said, "Angels can fly because they take themselves lightly."*

*G. K. CHESTERTON

Hibiscus in Cranberry Feet, 2004; Watercolor on paper;
15 × 14 inches; Collection of Claudia P. Casey

Ego on a Leash

The overzealous ego, now harnessed
on a short, tight leash,
exhausted from years of struggle
to understand, to be heard and seen,
now patiently awaits her next command
from her, "Somewhere," who's listening
for Divine Instructions.

Symbol in the Woods

Wet woods, glistening rocks,
slimy tree trunks. Wipe my glasses.
The drizzle begins again.

Walk, watch, listen for messages.
Down among shiny, rain-soaked leaves,
snuggled into dark rotted earth,

A small stone yoni, touched
by lichen and moss. Absolutely.
Symbol of the ancient Feminine.

Springing out from between its lips
a bright green sapling, full of promise.
New life from ancient mysteries.

Draw, caress it with my blue Pilot pen.
Want to hold on to it, remember
the earthiness of myself.

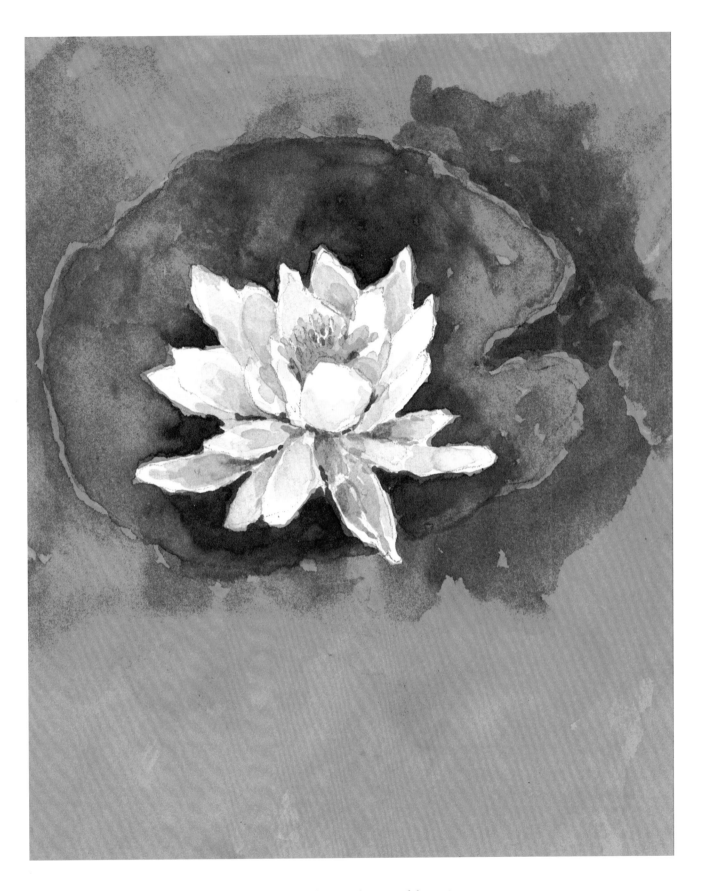

Lotus in Red, 2004; Watercolor on paper; 10½ × 9 inches; Collection of the artist

Words for her to read many years from now,
as her own heart breaks along the way to knowing.

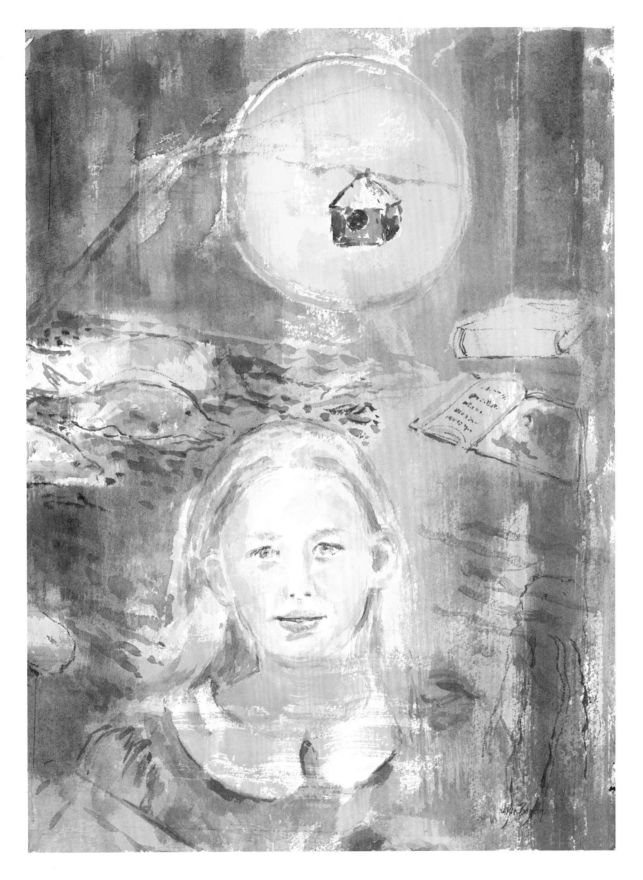

Audrey, Dream of Fishes, 2005; Watercolor and acrylic on paper; 22½ × 16½ inches; Collection of the artist

Dream of Man and Book

A man in robes sits behind a long ceremonial table or altar.
He is balding, wears glasses, not particularly handsome, but kind.
A large, thick book in front of him … a bible or book of knowledge.

He seems to be teaching people in rows and rows of chairs.
I sit across from him, my chair pulled up, right hand on the book,
leaning in as close as possible, perhaps even touching his arm.

I feel an overwhelming sense of longing, urgency. Unashamed
of sitting so close, I am solely focused on the man and his book,
unaware of the other people. I am completely naked.

Afterwards, lapsed back into social behavior, I feel undressed,
uncomfortable, think he must want to avoid me now. Not at all.
He comes to me, looks at me in my nakedness, tells me I am beautiful.

With the others, I try to hide myself, cannot find enough clothes
to cover me. I hide in a small room with three windows.
My friends peer in. I cannot hide.

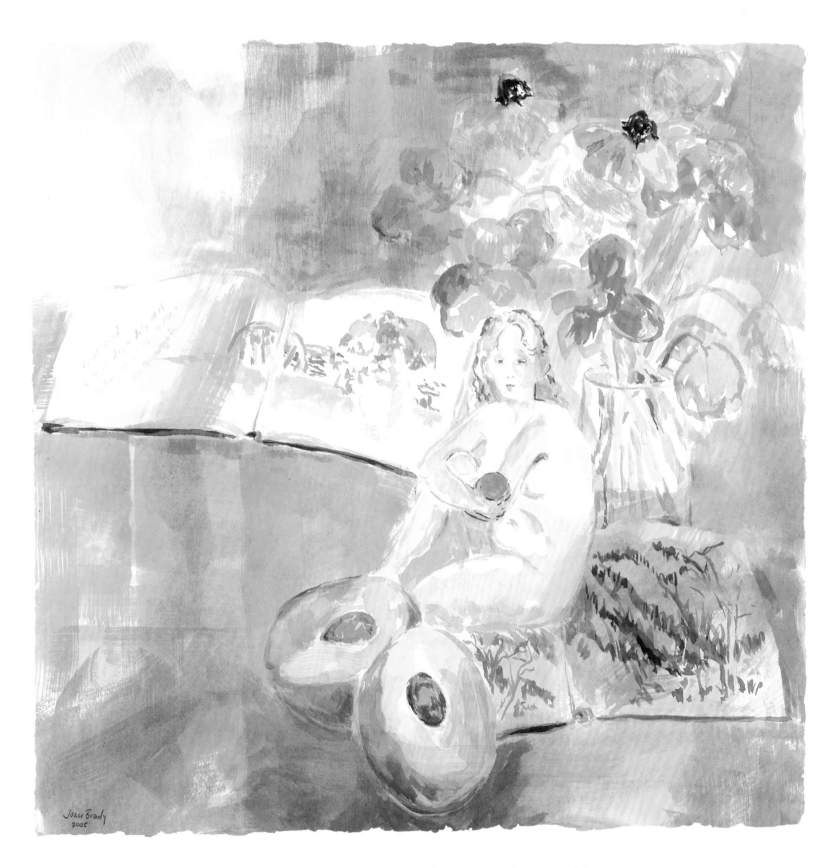

Peaches, Nude, and Sketchbooks, 2005; Watercolor and acrylic on paper; 21¾ × 22 inches; Collection of the artist

Which One is the Real One?

Which one is the Real One, the Beloved?
The one who suddenly is here,
all around me, so close.
Not quite close enough to touch.

The one who lives in Now,
not then ... or when.
The Presence telling me to trust
without my needing to see.

Or the one who speaks my name,
showers me with attention,
brings me to my knees,
blows open my sensibilities,

thrusts me into the void,
where the ground disappears.
Paintings and poems tumble out
from there without effort.

Which is the Real One ...
or are they one and the same?

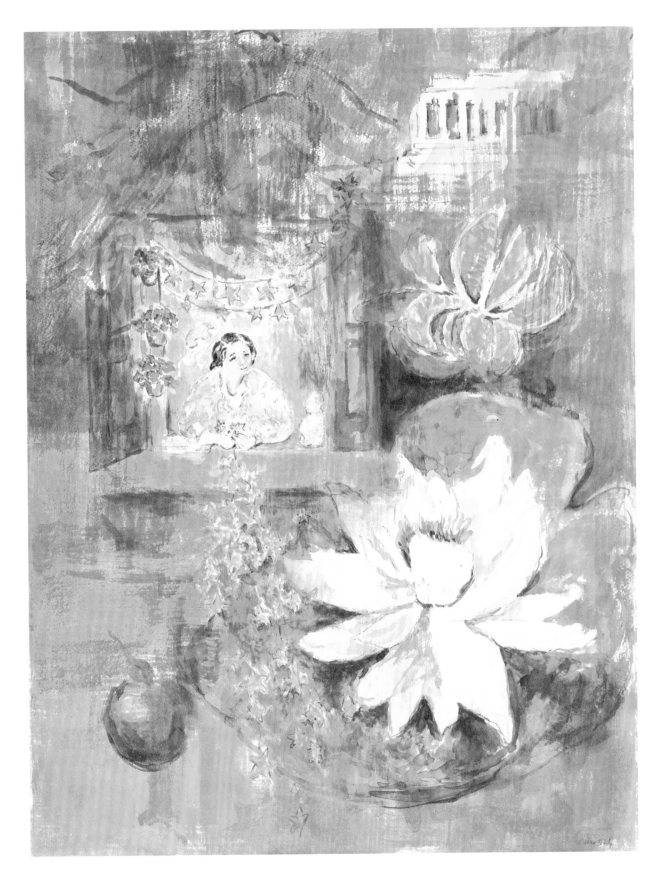

Woman in the Window, 2005; Watercolor and acrylic on paper; 30 × 23 inches; Collection of the artist

Dream the Night I Returned from Morocco

An old woman comes, like Mother Teresa,
less angular, same height.
Brown face and hands
between milk and dark chocolate.

Blue djellaba, sapphire to midnight blue,
the color of Nut's night sky.
I'm yearning, agitated, hurting for union,
for someone earthly, a man of this world.

She flashes the back of her hand at me,
as if to dismiss those thoughts.
Impatient with me, she tells me
there's no time to lose.

Now she's my teacher.
More and more I'm immersed.
She leads me into giving up one,
another, then another attachment.

As I try to hold on, even lightly,
she pushes me to let go. Down
to almost nothing. Nothing left at all.
Darkness … then, suddenly, dazzling light.

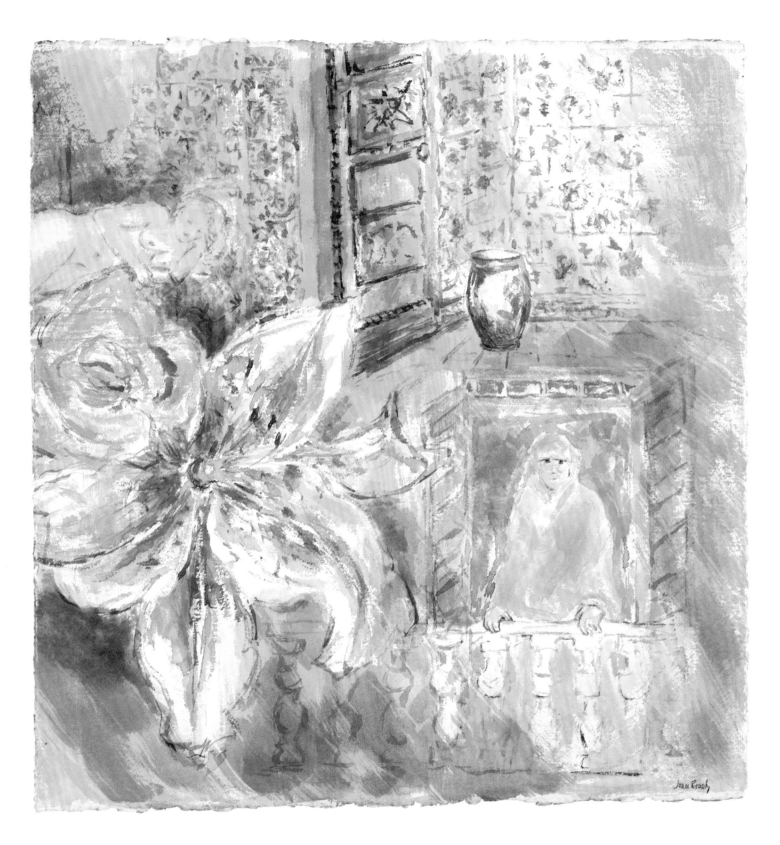

Moroccan Memories, 2005; Watercolor and acrylic on paper; 22½ × 26½ inches; Collection of the artist

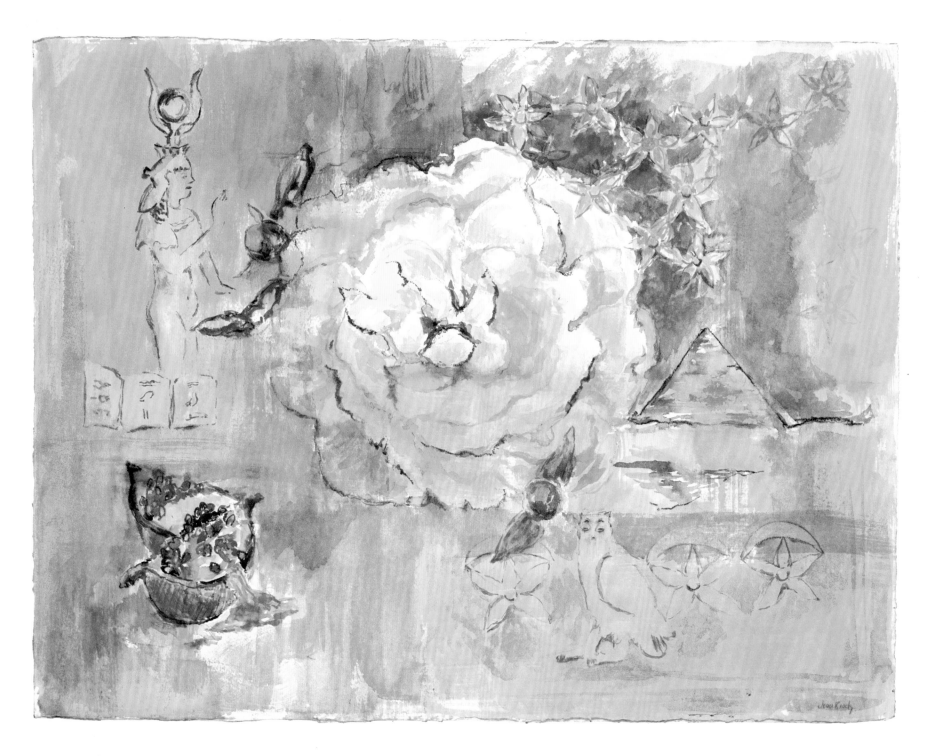

Memories of Egypt, 2005; Watercolor and acrylic on paper; 22¾ × 30 inches; Collection of the artist

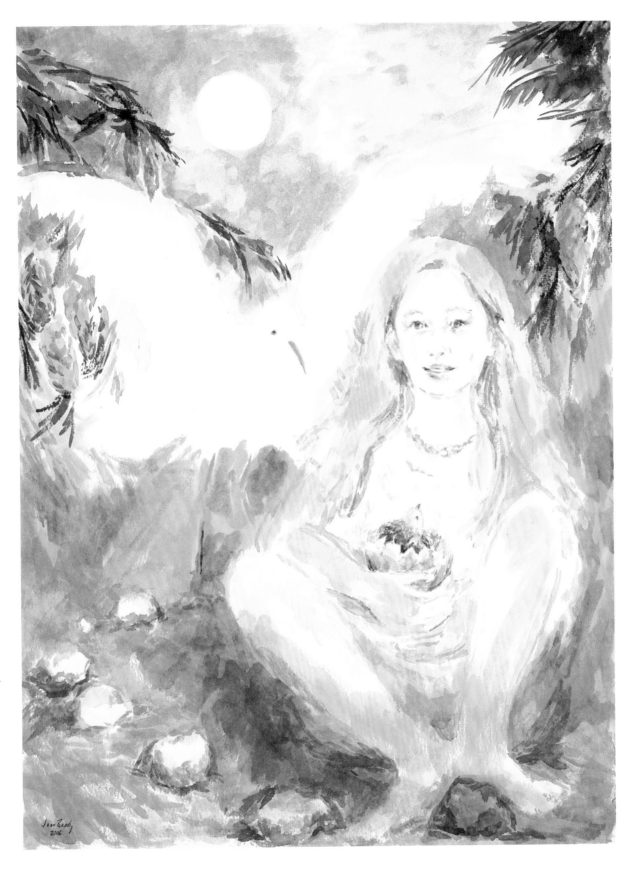

Circle of Stones, 2006; Watercolor and acrylic on paper; 29¾ × 22 inches; Collection of the artist

Snake Dreams

A luminous blue snake
in my possession. Try to hold
on to it, keep it under control.
Down by my side, out of sight.

Suddenly, it disappears,
shoots up between my legs,
takes me by surprise.
Electrifies me throughout.

Don't want anyone to see it,
quickly pull it up and out
of my body, out of my throat,
my mouth. And hide it.

Don't want anybody to see it,
but I loved the way it felt . . .
and I can feel it still.
And still through the years.

Another dream, a full decade
later. Pregnant by the snake.
Wondering what will be born.
What can I no longer hide?

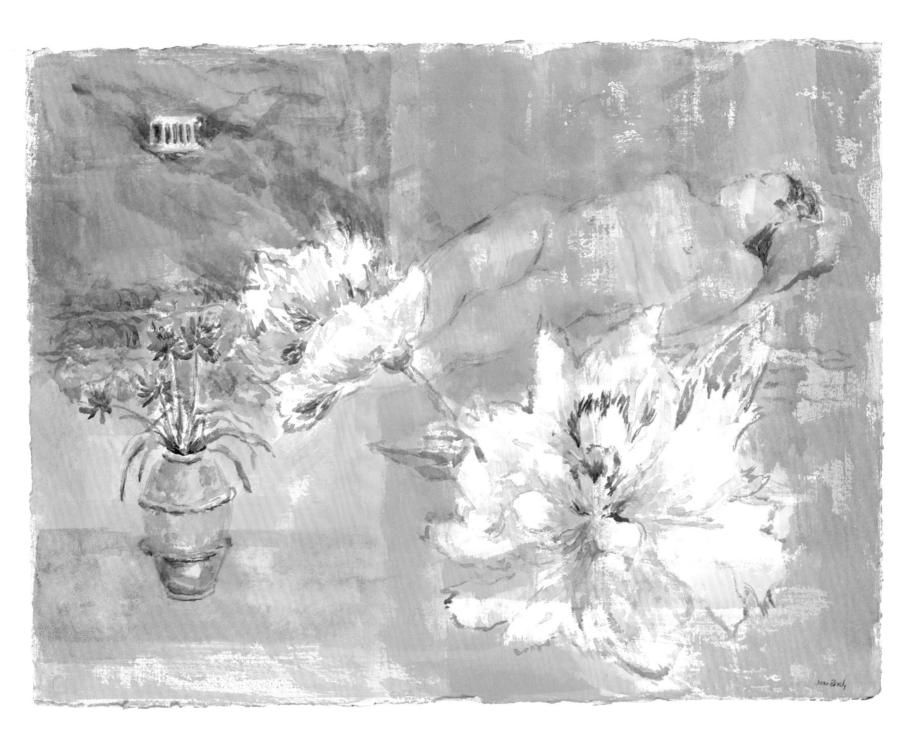

Divine Feminine, 2005; Watercolor and acrylic on paper; 30¼ × 22½ inches; Collection of the artist

Reconciliation

On the edge of two worlds,
or somewhere in between,
she hovered, slightly
outside each sphere.

Her two mandalas,
like planets, move slowly
towards each other as
resistance fades away.

Now she sits in herself,
reconciled in a state of love,
the Feminine, the almond center
of the mandorla she calls Home.

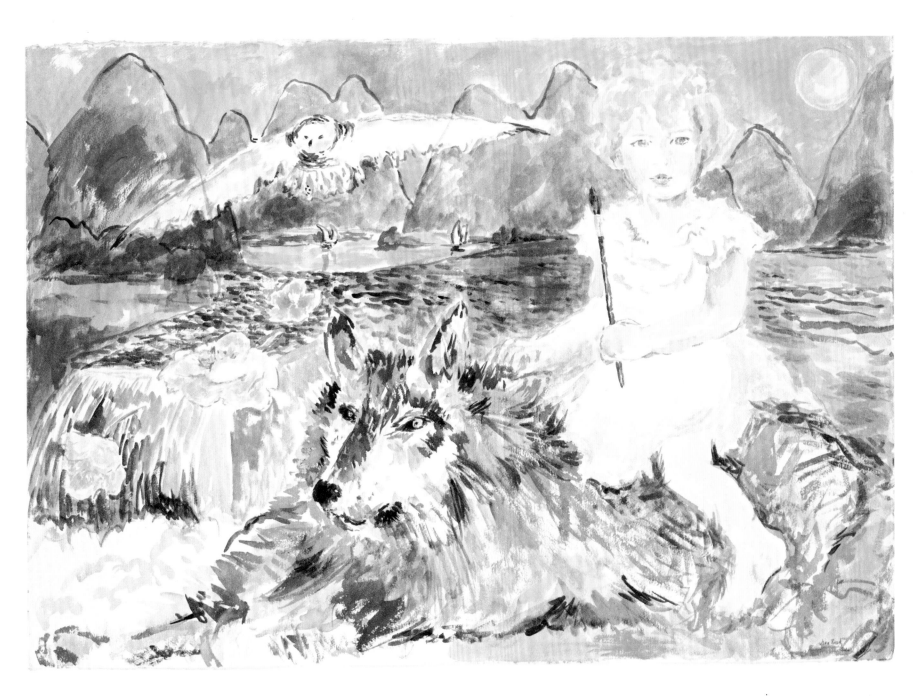

Girl on Wolf, Remembering, 2006; Watercolor and acrylic on paper; 30 × 40 inches; Collection of the artist

LIST OF PAINTINGS

FRONTMATTER

Nasturtiums and Sketchbooks, 2005
Watercolor on paper; 15 × 15 inches
Collection of the artist

Self-Portrait in Studio, 1983
Watercolor on paper; 22 × 22 inches
Collection of Mr. and Mrs. Wilson Nolen

HOME

Jim and Nonie, 1962
Watercolor and charcoal on paper; 12 × 10 inches
Collection of the artist

Kerry and Her Friends, 1969
Watercolor and ink on paper; 14 × 20 inches
Collection of the artist

My Dressing Table, 1983
Watercolor on paper; 22 × 24 inches
Collection of the artist

Bedside Table with Doll, 1982
Watercolor on paper; 18 × 22 inches
Collection of Vincent B. Murphy family

Breakfast in Bed #1, 1982
Watercolor on paper; 22 × 28 inches
Glenn Janss Collection

Breakfast in Bed #2, 1982
Watercolor on paper; 22 × 28 inches
Collection of Mr. and Mrs. Philip D. Allen

My Chair, 1980
Watercolor on paper; 16 × 20 inches
Collection of Mr. and Mrs. Philip D. Allen

Sketch of Jimmy in Library, 1991
Pen and ink in sketchbook; 10 × 8 inches
Artist's sketchbook

Sketch of Jimmy's Head, 1991
Pen and ink in sketchbook; 10 × 8 inches
Artist's sketchbook

Lemon Glass and Daffodils, 1975
Watercolor on paper; 14¼ × 11 inches
Collection of the artist

Black Forest Cake, 1984
Watercolor on paper; 22 × 30 inches
Collection of Crum and Forster

July Bouquet, Green Sofa, 1983
Watercolor on paper; 22 × 25 inches
Collection of Jane and Bob Carroll

Sketch of Jim with Cecily Parsley, 1990
Pen and ink in sketchbook; 10 × 8 inches
Artist's sketchbook

Initiation, 1987
Watercolor on paper; 22 × 29 inches
Collection of Nonie and Wilhelm Merck

New Slippers on a Hooked Rug, 1985
Watercolor on paper; 22 × 30 inches
Collection of the artist

May Garden from Living Room, 1990
Oil on canvas; 30 × 24 inches
Collection of Mr. and Mrs. Peter W. May

Puppy in Quilts, 1981
Watercolor on paper; 11 × 14 inches
Collection of the artist

Sunday Breakfast with Croissant, 1984
Watercolor on paper; 22 × 30 inches
Collection of Brooke Stoddard

Kitchen Bouquets with Fresh Eggs, 1985
Watercolor on paper; 20½ × 22½ inches
Collection of Mr. and Mrs. Charles E. Hance

Eggs, 1981
Watercolor on paper; 9¼ × 10½ inches
Collection of the artist

Ratatouille, 1977
Watercolor on paper; 11 × 14 inches
Collection of Mrs. B. Rionda Braga

Soft-Boiled Egg, Lazy Susan, 1984
 Watercolor on paper; 22 × 30 inches
 Private collection

Sketch of Audrey as Baby, 1997
 Sepia pencil on paper
 Collection of the artist

Dinner in the Kitchen for Four, 1998
 Watercolor on paper; 40 × 30 inches
 Collection of the artist

Kitchen Table, Bird House, Cookie Jar, 1991
 Oil on canvas; 40 × 34 inches
 Collection of the artist

Audrey and Millicent Painting in Kitchen, 2003
 Watercolor on paper; 30 × 22 inches
 Collection of the artist

Porcelain Birdcage in Window, 1992
 Oil on canvas; 36 × 30 inches
 Collection of the artist

Millicent, Birdcage, Peony, 2006
 Watercolor and acrylic on paper
 Collection of the artist

Audrey, Flowers, Fish, 2006
 Watercolor and acrylic on paper; 30 × 40 inches
 Collection of the artist

Just Desserts, 1985
 Watercolor on paper; 22 × 30 inches
 Collection of Sylvia and Joe Frelinghuysen

Next to the Christmas Tree, 1985
 Watercolor on paper; 22½ × 30 inches
 Collection of the artist

Full Christmas Tree, 1984
 Watercolor on paper; 41¼ × 29⅛ inches
 Collection of the artist

The Visit, 1994
 Watercolor on paper
 Collection of the artist

IN THE STUDIO

Studio from Bedroom Window, 1982
 Watercolor on paper; 18 × 22 inches
 Collection of the artist

Hibiscus & Sketchbooks, 2006
 Watercolor on paper; 15 × 15 inches
 Collection of the artist

Dahlias, Japanese Anemones in Studio, 1985
 Watercolor on paper; 30 × 22½ inches
 Collection: Mr. and Mrs. Henry L. Hillman

Onions, 1978
 Watercolor on paper; 8 × 10 inches
 Collection of the artist

Cup and Saucer, 1988
 Oil on canvas; 10 × 8 inches
 Collection of the artist

Next to The Studio Sink, 1990
 Oil on canvas; 26 × 22 inches
 Private collection

Afternoon in the Studio, 1988
 Oil on canvas; 30 × 24 inches
 Collection of Mr. and Mrs. Peter W. May

Favorites on a Chippendale Table, 1985
 Watercolor on paper; 22½ × 30 inches
 Collection of Mr. and Mrs. George B. E. Hambleton

Painting Glass Tree Balls, 1992
 Watercolor on paper; 30 × 22 inches
 Collection of the artist

Orchid and Oil, 1998
 Watercolor on paper; 30¼ × 22½ inches
 Collection of Nonie and Wilhelm Merck

Porcelain Swan with Peonies, 1985
 Watercolor on paper; 22½ × 22¼ inches
 Collection of Mr. and Mrs. Philip D. Allen

Blueberries in the Studio, 1984
 Watercolor on paper
 Collection of Howard Berkowitz

Piecrust Table, 1991
 Oil on canvas
 Private collection

Study for Peonies, 1999
 Watercolor on paper
 Collection of the artist

Pink Pitcherful, 2004
 Watercolor on paper; 23 × 17½ inches
 Collection of Mr. and Mrs. Richard F. Brueckner

Summer Flowers and Clippers, 1985
 Watercolor on paper; 22¼ × 30 inches
 Collection of The Newark Museum

Waterfall from Studio, 1992
 Oil on canvas; 40 × 34 inches
 Collection Susan and John Jackson

Open Matisse, 1987
 Watercolor on paper; 29 × 22 inches
 Collection of Mr. and Mrs. John G. Ordway

Audrey in Pink Smock, 1999
 Watercolor on paper; 30 × 22 inches
 Collection of Anne and Jim Brady

April Studio, Rugalach in Cranberry Glass, 1987
 Watercolor on paper; 40 × 26¼ inches
 Collection of Cathy and Bill Ingram

Two Patterns, Lalique Vase, 1987
 Watercolor on paper; 40 × 29 inches
 Collection of Patricia Hagen

Two Green Apples on Dish Cloth, 2005
 Watercolor on paper; 11½ × 17 inches
 Collection of Susan and John Jackson

IN GARDENS

View of Garden from Kitchen, 1986
 Watercolor on paper; 22 × 22 inches
 Collection of Cathy and Bill Ingram

Pastel of Garden, 1980
 Pastel on paper; 11 × 14 inches
 Collection of the artist

July from Studio Steps, 1994
 Watercolor on paper; 29½ x 41½ inches
 Private Collection

Studio Garden, July, 1994
 Watercolor on paper; 29½ × 41½ inches
 Collection of the artist

Peonies on Glass Table with Clippers, 1999
 Watercolor on paper; 30 × 22 inches
 Collection of the artist

Tulips Daffodils Dendrobian, 1987
 Watercolor on paper; 22 × 30 inches
 Collection of Cathy and Bill Ingram

House of Flowers, Flowers and Houses (detail), 1986
 Watercolor on paper; 40 × 29 inches
 Collection of the artist

Chaise Longue, July Garden, 1994
 Watercolor on paper; 30 × 40 inches
 Collection of the artist

Cosmos, 1977
 Watercolor on paper; 18 × 24 inches
 Collection of Buff and Johnnie Chace

Mill Neck Bouquet, 1977
 Watercolor on paper; 24 × 18 inches
 Collection of the artist

Zinnias, 1977
 Watercolor on paper; 18 × 24 inches
 Collection of Elizabeth Boies Schley

Peonies and Centaurea, 1982
 Watercolor on paper; 22 × 28 inches
 Private collection

Strawberries for Henry and Liberty, 2004
 Watercolor on paper; 19 × 14 inches
 Collection of Henry and Liberty Yates

Flowers and Vases in Pantry Sink, 1993
 Watercolor on paper; 41 × 30 inches
 Collection of the artist

Birdbath, Garden, Bridge, 1999
 Watercolor on paper; 30 × 22½ inches
 Collection of Mr. and Mrs. Philip D. Allen

Fountain and Phlox Divaricata, 1987
 Watercolor on paper; 22 × 22 inches
 Collection of the artist

Haybales, 1999
 Watercolor on paper; 40 × 30 inches
 Collection of the artist

Smoosh of Peonies, 1999
 Watercolor on paper; 15 × 18 inches
 Collection of Mr. and Mrs. Frank A. Kissell

VOYAGING OUT

Undertow, 2001
 Watercolor on paper; 9 × 12 inches
 Collection of the artist

Winter Scene, 1979
 Watercolor on paper; 14½ × 20½ inches
 Collection of Mr. and Mrs. Gordon A. Millspaugh

Barn in Snow, 1979
 Watercolor on paper; 14½ × 20½ inches
 Collection of Kim Brady Cutler

Goatherd in Antigua, 1969
 Watercolor on paper; 14 × 20 inches
 Collection of the artist

Antigua, 1969
 Watercolor and ink on paper; 14 × 20 inches
 Collection of the artist

Sketch of Boat on the Waterway, 1998
 Pen and ink in sketchbook; 10½ × 8 inches
 Artist's sketchbook

Steps of Flowers, Light on Waterway, 1998
 Watercolor on paper; 30 × 23 inches
 Collection of Mrs. Edward H. Gerry

Swimming Pool, Blue Vase, 1997
 Watercolor on paper; 30 × 22½ inches
 Collection of Mr. and Mrs. Stuart L. Scott

Kerry in Straw Hat, 1978
 Watercolor on paper; 17 × 20 inches
 Collection of the artist

Orchids and Patterns, 1999
 Watercolor on paper; 40 × 30 inches
 Collection of David Dewey

Mostly Poppies in a Starfish Vase, 1999
 Watercolor on paper; 30 × 22⅝ inches
 Collection of the artist

Luberon, 1985
 Watercolor on paper; 22 × 30 inches
 Collection of Paul and Mary Lambert

Menerbes from Les Martins, 1985
 Watercolor on paper; 24 × 22½ inches
 Collection of Mr. and Mrs. Finn M. W. Caspersen

Poppies, Pansies, and Paintings of Provence, 1985
 Watercolor on paper; 22¼ × 21½ inches
 Collection of the artist

Hibiscus in Cranberry Feet, 2004
 Watercolor on paper; 15 × 14 inches
 Collection of Claudia P. Casey

Lotus in Red, 2004
 Watercolor on paper; 10½ × 9 inches
 Collection of the artist

Audrey, Dream of Fishes, 2005
 Watercolor and acrylic on paper; 22½ × 16½ inches
 Collection of the artist

Peaches, Nude, and Sketchbooks, 2005
 Watercolor and acrylic on paper; 21¾ × 22 inches
 Collection of the artist

Woman in the Window, 2005
 Watercolor and acrylic on paper; 30 × 23 inches
 Collection of the artist

Moroccan Memories, 2005
 Watercolor and acrylic on paper; 22½ × 26½ inches
 Collection of the artist

Memories of Egypt, 2005
 Watercolor and acrylic on paper; 22¾ × 30 inches
 Collection of the artist

Circle of Stones, 2006
 Watercolor and acrylic on paper; 29¾ × 22 inches
 Collection of the artist

Divine Feminine, 2005
 Watercolor and acrylic on paper; 30¼ × 22½ inches
 Collection of the artist

Girl on Wolf, Remembering, 2006
 Watercolor and acrylic on paper; 30 × 40 inches
 Collection of the artist

EXHIBITIONS

SOLO EXHIBITIONS

2005
"Ordinary Pleasures"
Riverside Studio, Pottersville, NJ

2001
"Presence"
Riverside Studio, Pottersville, NJ

2000
"Joan Brady: Her Gardens"
Tatistcheff & Co., New York, NY

1995
"Moments out of Time"
Riverside Studio, Pottersville, NJ

1993
"Joan Brady Paintings"
Midtown Payson Galleries, Hobe Sound, FL

1992
"Joan Brady: Interiors and French Landscapes"
Tatistcheff & Co., New York, NY

1990
"Joan Brady—Oil Paintings and Small Watercolors"
Tatistcheff & Co., New York, NY

1987
"Joan Brady Watercolors"
Tatistcheff & Co., New York, NY

1985
"Joan Brady Watercolors"
Tatistcheff & Co., New York, NY

1983
"Joan Brady Watercolors"
Tatistcheff & Co., New York, NY

1977
Spook Farm Gallery, Far Hills, NJ

1973
Spook Farm Gallery, Far Hills, NJ

1970
Country Art Gallery, Locust Valley, NY

1968
Spook Farm Gallery, Far Hills, NJ

GROUP EXHIBITIONS (SELECTED)

1989
Tenth Anniversary Exhibition
Tatistcheff & Co., New York, NY

1987
"The Flower in 20th Century American Art"
Southern Alleghenies Museum of Art, Loretto, PA

1986
"Nature Morte"
Southern Alleghenies Museum of Art, Loretto, PA

1985
"American Realism: Twentieth Century Watercolors and Drawings"
from the Glenn Janss Collection; Exhibition organized by The San Francisco
Museum of Modern Art, and traveling to:

San Francisco Museum of Modern Art
7 November 1985–12 January 1986

DeCordova and Dana Museum and Park, Lincoln, MA
13 February–6 April 1986

Archer M. Huntington Art Gallery, University of Texas, Austin
31 July–21 September, 1986

Mary and Lee Block Gallery, Northwestern University, Evanston, IL
23 October–14 December 1986

Williams College Museum of Art, Williamstown, MA
15 January–8 March 1987

Akron Art Museum, Akron, OH
9 April–31 May 1987

Madison Art Center, Wisconsin
26 July–20 September 1987

1985
"The New American Scene"
Squibb Building, Princeton, NJ

1983
"A Sense of Place"
Spook Farm Gallery, Far Hills, NJ

1982
Selected by curator for group exhibition at Nabisco Gallery,
East Hanover, NJ

1975
FAR Gallery, New York, NY

1966–1967
Galleries in New Jersey and Boston

ARTIST BIOGRAPHY

1934
Joan Babcock born May 27, New York, NY

1957
Married June 27 to James C. Brady

1958
Jim Brady III born November 16

1960
Nonie Brady born December 30

1964
Kerry C. Brady born June 15

ART EDUCATION

1952–1954
Art major, Briarcliff College, NY

1954–1958
Art Students League, New York, NY
Studied with: Robert Brackman, Harry Sternberg, George Gross

1956–1957
Studied painting with Paul Wood, Port Washington, NY

1975–1981
Painted with Aaron Shikler and David Levine
Wednesday night Art Class, New York, NY

RESIDENCIES AND RETREATS (RECENT)

2002 & 2003
Women's Writers retreat with Deena Metzgar, Pine Mountain, CA

2004
One month writer's residency at Vermont Studio Center, Johnson, VT

2005 & 2006
One month artist's residency at Vermont Studio Center, Johnson, VT

2007
One month artist-writer's residency at Vermont Studio Center, Johnson, VT

REVIEWS AND REPRODUCTIONS

1968, 1970, 1973, 1977, 1983, 1985, 1990, 2000
The Bernardsville News, NJ; Reviews by Rachel Mullen

1983
Art World, vol. 8 no. 3, December 1983
Review of one-man show at Tatistcheff & Company
by Richard Hunnewell

1985
Art News
Review of one-man show at Tatistcheff & Company
by Joannah Wilmerding

1986
American Realism: Twentieth Century Watercolors and Drawings from the Glenn Janss Collection; Foreword by Henry T. Hopkins; Joan Brady, pages 153, 208, 142; Published by Harry N. Abrams, New York

1991
Art Forum, February 1991
Review of 1990 show at Tatistcheff & Company

1991
Courier News, July 1, 1991
Article on Joan Brady's art by Emanuel Haller

1995
The Watercolor Book: Materials and Techniques for Today's Artist by David Dewey; Watson Guptill Publications, NY; Joan Brady, "Garden Sketchbook," page 36

PUBLICATIONS

1999
Another Kind of Time, a memoir with watercolor sketches
Published by aah-ha Books, Inc., NY

ACKNOWLEDGMENTS

A most heartfelt and enormous thank you to my beloved production team who I hope will continue to work with me.

To Renate Stendhal, my editor, for her wisdom and gentle "tweakings," for giving courage and encouragement to my voice, for protecting me from myself. For becoming a good friend.

To Mike Newman at Digital Arts Imaging for the hours and hours of his time spent color-correcting and preparing the images in this book, for the pleasure of working side by side with him.

To Christopher Kuntze for his careful attention to detail in collecting and connecting all of the pieces of my homemade book and putting it into such beautiful form.

To Jay Stewart and Capital Offset for the final physical manifestation of *Between Brushstrokes*.

To Leslie van Breen and Hudson Hills Press for publishing and distributing my book.

To Kathy and Paul Rust/Riverside Studio for unframing, reframing, borrowing, and carrying paintings back and forth to be photographed at Digital Arts Imaging.

To my Jimmy for being excited about the book, for never complaining as his wife and our life were taken over by this "child" that has finally been born.

To my encouragers who spent time with me, reading, looking at, and listening to the book-in-progress through its many incarnations: Raechel Bratnick, Diana Hambleton, Susan Jackson, Sinikka Laine, and Bill Black.

To the owners of the paintings in the book as well as to the other collectors of my work whose paintings I could not use or did not have a good enough image of.

—— *Another Kind of Time* by Joan Brady ——

"Joan B. Brady has invited us into the heart and soul of the private world that she shared with her mother. It is an elegant tribute to the best of our humanity, when it is inspired by love."

Deepak Chopra, author of *The Path to Love*

"*Another Kind of Time* is a moving, intimate picture of the relationship between a loving daughter and her dying mother. It is about the spiritual connections that grow stronger toward life's end. A valuable contribution."

Larry Dossey, MD, author of *Healing Words*

To purchase copies of *Another Kind of Time* as well as limited edition prints visit the website: www.joanbrady.com